SECRET OSWESTRY

John Idris Jones

AMBERLEY

The author dedicates this book to his grandchildren, Billy and Poppy of Ruthin.

First published 2019

Amberley Publishing
The Hill, Stroud
Gloucestershire, GL5 4EP

www.amberley-books.com

Copyright © John Idris Jones, 2019

The right of John Idris Jones to be identified as the
Author of this work has been asserted in accordance
with the Copyrights, Designs and Patents Act 1988.

ISBN 978 1 4456 8734 6 (print)
ISBN 978 1 4456 8735 3 (ebook)

British Library Cataloguing in Publication Data.
A catalogue record for this book is available from the
British Library.

Origination by Amberley Publishing.
Printed in Great Britain.

Contents

Introduction

The 'secret' of Oswestry is the product of its long history as a border town situated between the Celts to the west and the Angles, Picts, Vikings and Saxons to the east, changing hands many times. It goes back through the so-called Dark Ages to the Romans, and before that to the inhabitants of the land, especially those who, extraordinarily, lived on the even top of the nearby hill some 3,000 years ago during the late Bronze Age and the Iron Age.

In the words of Newman and Pevsner, I have perambulated the town, using their superb book on the buildings of Shropshire as a guide, which explains the background to features, streets and architecture. In addition, I have researched its history – as much of it as I could find – and for centuries (including the faintly drawn Arthur) there is little to go on. It looks as if northern Wales (and largely before it had that name) was much larger in the early centuries than it is now. Some historians have it stretching as far as the Mersey, covering half of what is now Cheshire and most of north-west Shropshire.

So Oswestry sat in Welsh territory for much of the time. My good friend and informant Prof. Gruffydd Aled Williams, originally from the Corwen district, speaks of visiting a barber in Oswestry who grew up in the town speaking Welsh. He says that in his early manhood he attended a dance in Oswesry where more Welsh was spoken than in similar events in Welshpool and Wrexham!

I was born and spent my early years in Llanrhaeadr-ym-Mochnant, a village in the Berwyn mountains, some 13 miles west of Oswestry. The village had its domestic supplies – tea, bread, meat etc. – but we relied on Oswestry for the more sophisticated items. We spoke in Welsh and called it Croesoswallt. I recall a shop at The Cross with large windows, displaying ladies' hats on poles, and on Sundays the newspapers came from Oswestry in a car, parking on the square in Llanrhaeadr, handing the papers out through the windows.

In Oswestry we are dealing with a hybrid market town. It cannot properly be presented on its own. It has ineradicable links with its outliers (as Newman and Pevsner call them). This hinterland has palpable historical lines of connection. Baschurch, a few miles north of Shrewsbury, is mentioned in Welsh poetry of the ninth century as a place of warriors who have been defeated in battle. An old house there facing the church carries the name 'Ty Nain' (grandmother's home). Whitchurch, also some distance from the Welsh border, has a castle that was captured by a number of Welsh chiefs. The rich countryside of Shropshire includes places with Welsh names, which acknowledge their historical origins – Welsh Frankton and Welshampton for instance. The history of Oswestry is varied and complicated, and not fully understood.

One day in Oswestry, when I was searching for the first home of Wilfred Owen (who was the outstanding poet of the First World War), Plas Wilmot, I turned my car into a cul-de-sac carrying the name Wilmot, but it was not the right place. As I turned my car around at the end, I was approached by the house owner. He introduced himself as a man of Oswestry ('Lived here all my life – I had a butcher's shop'). 'Interesting place', I said. 'Full of history'. 'And yet', he replied, 'I have not quite felt fully at home here. I don't really know who I am.' 'But you are a Celt, like me', I asserted. At this, his shoulders straightened and his eyes shone.

1. Hill Fort ('Old Oswestry')

DID YOU KNOW?
During pre-Roman times a Celtic tribe lived on a hilltop near Oswestry.

As you drive into Oswestry from the east, on your right you see a long hill with a flat top. This is the old hill fort, which was more of a place of living and surviving for the people of the late Bronze Age, the Iron Age and the time of the Romans. It was occupied for some 1,000 years.

It is a fine example of a multiple rampart hill fort of which there are many in eastern Wales and the Marches. Its ramparts and ditches can be clearly seen – five on the east and seven on the west. On the east and west sides there are signs of entrances. The one on the west is a sunken lane ascending the hill, with raised sections on both sides, for defence. Peculiar to Oswestry, on both sides there are excavated hollows, suggesting animal holding areas, pointing to the agricultural life of the homestead. The site dates back to the late Bronze Age, and the defences, excavated, reveal an age of 600 BC, when the west entrance was reconstructed.

People lived at the hilltop during the Neolithic period through to Roman times. The main settlement was during the later Bronze Age and during the Iron Age (from around 1000 BC to AD 43). Stone axes and flint tools have been excavated.

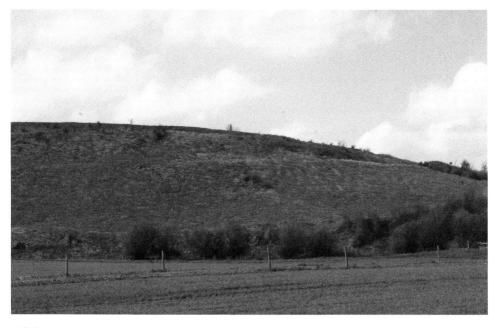

Hill fort, Oswestry.

The area was surrounded by a palisade. Inside were round houses built of posts and wattle-and-daub walls, headed by a thatched roof, and there was a hearth inside. A pottery crucible was excavated, showing that bronze melting was taking place. Iron Age (*c.* seventh century BC) pottery from Wiltshire was excavated as well as salt containers from Cheshire, showing long-distance trading. The hill was surrounded by fields and inhabitants here could use the hill fort as a place of refuge during conflicts.

2. The Kingdom of Powys

Powys is the name of the current county within Wales that stretches down the eastern border. This is not to be confused with the old territories of Powys and Powys-Fadog, which consisted of the northern parts of the present county and more.

From the fifth century to 1160, the Kingdom of Powys occupied northern Wales, to the east of the Kingdom of Gwynedd. Its language was Welsh and its religion Celtic Christianity. Its capitals were Cae Gurion, Pengwern (thought to be Shrewsbury), Mathrafal (Meifod), Welshpool and Chester. Parts of the West Midlands were included in this kingdom at various times. The area was influenced by the Romans and was dominated by two tribes: the Ordovices to the west and Cornovii in the east. After the Roman occupation, the area was part of a province, organised from Viraconium (modern Wroxeter), which was a Roman centre.

In the times of tribal Wales (before it was 'Wales') these eastern areas were much valued and fought-over for possession. The mountains of Gwynedd (Snowdonia) and the Berwyns, rocky and arid, are to the west, and then, suddenly, to the east the landscape changes as one enters the Cheshire and Shropshire plains, which are flat, undulating with the occasional low hill. Here the land is much richer, more fertile, being possessed of Triassic sandstone, facilitating water drainage, and much easier to cultivate. The present town of Oswestry is located just inside the plains area, so it was, when a small market town in the earlier and medieval period, affected by many insurgencies, attacks and takeovers, in a to-ing and fro-ing of successive battling tribes. Although its medieval buildings have mostly gone, its original street plan remains, with some buildings, such as Lloyd's Mansion, surviving, with parts dated *c.* 1580.

Oswestry, therefore, historically, is not on its own. It is linked with its surrounding landscape and settlements, particularly within a radius of, say, 15 miles. Here, to the east, there are many instances of occupation and settlement of the western forces, with Welsh place names, field and river names, defensive/domestic buildings and castles. So, we are dealing with a territory, not just a town.

The Kingdom of Powys was originally controlled by the Gwerthrynion dynasty, who claimed descent from the Roman chief Magnus Maximus. Viraconium was occupied well into the sixth century, 200 years after the Romans left. The large 'English' territory of Mercia encroached on the Powys eastern border, which was overcome in the late eighth century.

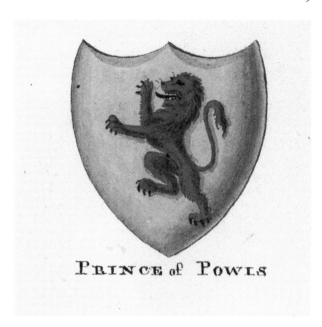

Prince of Powys emblem.

In 616 the armies of Aethelfrith of Northumbria clashed at Chester, invading Powys's northern land. In the seventh and eighth centuries there were Welsh successes, with Oswestry featuring. Offa's Dyke was built with Oswestry just on the English side, and Offa's men battled in the late eighth century and captured land. In 855 Rhodri the Great became King of Powys, as well as of Gwynedd.

The House of Mathrafal in 1263 controlled Powys. In 1282 Llywelyn the Last was killed and Edward I of England created a Marcher lordship, which brought the Welsh Kingdom of Powys to an end.

3. 'King' Arthur

Much has been made of this character, on very flimsy sources. We are fairly certain that Arthur existed as a military leader, but the large edifice of romantic stories featuring colourful court life, a magic stone, a sword and lake etc. are fiction. He was, in reality, a leader of men for purposes of power gain. He was a Celt who was in league with the western tribes. He was possibly named Owain Ddantgwyn and defended their land and possessions and pushed for them to gain more.

The Wroxeter Roman city of Viraconium was the fourth largest city in Roman Britain. We know from archaeology that the site was rebuilt after the Romans vacated it. This may well have been done by Celts who used it as a headquarters; this may be the original 'Camelot', the place where Arthur had his home and army.

Oswestry Old Fort features in the history. One of its names was Caer Ogyrfan, named after the legendary father of Guinevere, Arthur's wife. Another local story involves Whittington Castle: the Holy Grain is said to have been kept in the chapel.

Two ancient written accounts, the *Historia Brittonum* (*History of the Britons*) and *Annales Cambriae* (*Welsh Annals*), present Arthur as a Romano-British leader who fought against the Anglo-Saxons in the late fifth to early sixth centuries. The ninth-century *Historia* lists twelve battles fought by Arthur's army. One battle was located at 'The City of the Legions', which, because it was the HQ for the 20th Legion of the Roman army, was Chester. In this account by Nennius (in Latin, *c.* AD 830), Arthur is named three times as living around AD 500. His last battle is cited as the Battle of Badon, taken to be Bath. There was such a battle there in AD 500, chronicled by the British monk Gildas, coinciding with the life of Arthur, and, according to their records, the Anglo-Saxons were pushed back twice between AD 500 and 520.

So, there is some reasonably good evidence that the military leader Arthur existed. Given the archaeological evidence for the significant rebuilding of Viraconium after evacuation by the Romans, it is believed that Arthur and his army had his headquarters here.

A manuscript poem in Welsh, translated as 'Song of Llywarch the Old', exists in the Bodleian Library, Oxford University, dating from the seventh century. The work describes the battles fought by Cynddylan, who died fighting the Saxons in AD 658. The work describes him as a direct descendant of Arthur, who, earlier, fought on behalf of the Kingdom of Powys. Cynddylan was defeated by the Saxons, who took over eastern Powys.

There is a reference to Arthur in the late medieval manuscript Culhwch and Olwen – part of the Mabinogion stories (dated *c.* AD 1060). The romanticised account by Geoffrey of Monmouth, allegedly of an original Arthur, is not based on him but on a later figure.

King Arthur.

4. Owain Glyndwr

Owain has become a symbol of Welsh nationalism as a significant historical figure who believed in a united Wales. He studied law at one of the London Inns of Court and achieved the position of barrister. He was then appointed squire to Richard II, who knighted him. He was married early in life to Margaret, daughter of Sir David Hanmer, one of the Justices of Court of the king's bench. He had a hatred of Henry IV. He put his belief in to action and headed a fighting force that travelled all over Wales claiming land, property and political power. He was, by any measure, an extraordinary man. His assumed dates are 1359 to 1415, and he was the last Welshman to hold the title Prince of Wales (Tywysog Cymru).

His father, Gruffydd Fychan, was a descendant of the Princes of Powys and was Lord of Glyndyfrdwy, and his mother was descended from the last sovereign Prince of Wales.

Thousands flocked to Glyndwr's standard. A court document of the late 1400s lists around 200 men of Oswestry and district joining the Glyndwr rebellion. In 1400 the town was attacked and burned. On 16 September he instigated his rebellion against the occupation and rule of Wales by the forces of Henry IV of England. In 1403 Owain assembled his 4,000 soldiers in Oswestry to join Lord Percy (Henry Hotspur) against the king. The Battle of Shrewsbury had 12,000 men on Owain's side, but it is said that Owain saw the conflict from his hiding place in an oak tree, and withdrew his troops to Oswestry and back into Wales, while pursued by Prince Henry (late Henry V).

His movement was initially successful, but his troops suffered from a lack of artillery, necessary to capture defended castles, and ships, necessary for entry by sea.

Owain Glyndwr's banner and statue.

5. The Battle of Maserfield, AD 642

William Cathrall, in his book *History of Oswestry*, begins his section 'The British Period' with the following comment:

> For ages the site of the town, with its surrounding district, was the theatre of brutal contention, rapine, and aggrandisement ... Education had not spread her benign wings over the people to hush them in to peace; and too commonly they who possessed the strongest physical power and the wildest barbarian became, in turns, 'Lord of the Ascendant'.
>
> Oswald, son of Cunedda Wledig ... is its first monarch. [He] attacked the Mercian King Penda at Oswestry on August 5th, 642 AD. Oswald and Oswy were sons of Adelfrid, the seventh King of Northumberland. Penda was a pagan prince and had laid Northumbria waste. The site of the closing scene of this memorable battle is said to have been at a field called Cae Nef (Helen's Field) ... situated on the left of the turnpike road leading to the free school ... Oswald approached with his army to what is called Maes-y-Llan, or Church Field, about four hundred yards west of the church ... rising ground, where the battle began. Oswald was killed.

Oswald's remains lie at St Oswald's, Gloucestershire. He is the patron saint of soldiers.

Cathrall writes, 'From the death of Oswald to 777, Oswestry is reported to have been in the undisputed possession of the Britons.'

The usual name given to the battle, 'Maserfield', seems to conflate Welsh and English, '*Maes*' in Welsh meaning 'field'.

Battle of Maserfield.

6. Oswestry's Name

It is clear that the name of the town originates from King Oswald of Northumbria, who died in AD 641. Oswald, slain in battle at the site of Oswestry, had his remains slung on a tree, which is part of the English name. Legend has it that one of his limbs was carried away by an eagle, and where he dropped it became Oswald's Well, now in Oswestry town. The Welsh version Croesoswallt includes *'croes'* meaning cross, so the tree is seen as a cross.

Oswestry's coat of arms.

7. Oswestry Town

Oswestry is the third largest town in Shropshire, after Telford and Shrewsbury. It has a population of just over 17,000 according to the 2011 census. It is 5 miles from the Welsh border and lies at the junction of the ancient Roman road, the A5, with the A483 and A495.

In 1190 the town was granted the right to hold a market each Wednesday. A market town from early times, when it was a walled town, most of its medieval remains have gone. However, there are timber-framed buildings, the outstanding one being Lloyd's Manson at The Cross. Also, older buildings remain at the Heritage Centre, the Black Gate, the Fox Inn and shops along Beatrice Street. Georgian architecture is found around St Oswald's Church, and there are a number of impressive town houses, with grand staircases and impressive front doors with porches and steps. The Victorian era created many fine buildings including the outstanding railway station and the railway engineering building. Two important architects, Frank Geery and Thomas M. Penson, left their mark on the town.

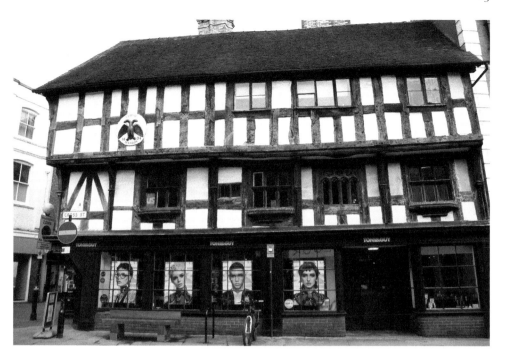

Lloyd's Mansion.

In 1674 Charles II granted a charter to the town. Local records cite markets and fairs, indicating local trading, with produce coming in from the rural hinterland – farmers coming in with eggs and meat from the Tanat Valley and suchlike. For centuries Oswestry was a strong Welsh settlement: the castle, built to dominate the Welsh, dates from around 1086, and was recorded in William I's Domesday Book. The area was occupied by the Celtic Welsh ('Britons') and the Anglo-Saxons prior to the Norman Conquest.

Behind the town is the site of the old racecourse, known as Cyrn-y-Bwch, and its highest point is at 1,000 feet above sea level. Walkers enjoy it here, including Candy Woods, and Offa's Dyke passes through. From the 1700s to 1848 it was based between England and Wales in order to attract horse-owning landowners and gentry, and the track was a figure of eight shape.

At outbreak of the English Civil War between Royalists and Parliamentarians in 1642, the town initially declared for Charles I. In 1644 the castle was laid siege by Thomas Mytton of Halston Hall (near Whittington), who was joined by the Earl of Denbigh. The castle submitted and its Royalist troops surrendered.

Oswestry is the home of one of the oldest schools in Britain. The original Oswestry School was founded in 1407. It was a 'free' school, meaning that it was not linked to any ecclesiastical foundation. The old school's fifteenth-century site, adjacent to the parish church, is now a heritage and information centre.

Notable people connected with the town include W. A. Spooner, Oxford don and originator of Spoonerism; Sir Henry Walford Davies, composer and Master of the Queen's Music 1934–41; Wilfred Owen MC, First World War solder and poet; Ivor Roberts-Jones RA (1913–96), creator of the sculpture of Winston Churchill in Parliament Square;

Thomas M. Penson (born in 1818 in Oswestry), surveyor and architect; and Ian Woosnam OBE, professional golfer.

8. William Morgan – Llanrhaeadr-ym-Mochnant Church

DID YOU KNOW?
The Bible was translated to Welsh in Llanrhaeadr-ym-Mochnant.

William Morgan was Wales's outstanding scholar, an intellect who dealt with ancient languages as well as contemporary vernacular prose.

Born in 1545, his life invites comparison with his near-contemporary William Shakespeare, who was also born in humble circumstances and rose to create great work in writing.

William Morgan's birthplace was in deep countryside, in an isolated stone cottage, Ty Mawr, in Wybrnant, between Penmachno and Betws-y-Coed. It is accessed today from Penmachno through miles of forest road. His father was a tenant of the Gwydir estate and he may have been educated at Gwydir Castle, near Llanrwst, the home of the rich and influential Wynn family. His father was John and his mother Lowri and he was the youngest of five children.

He moved to Cambridge where he studied at St John's College. His subjects included Greek, mathematics and philosophy. He graduated with a BA in 1568 and an MA in 1571. Then followed seven years of Biblical studies, with close attention to Greek, Hebrew and Aramaic, obtaining his BD in 1578 and DD in 1583.

In 1568 he became a clergyman of the Church of England. He took up offices at Llanbadarn Fawr, Welshpool, and became vicar of Llanrhaeadr-ym-Mochnant in 1578, where he translated the Bible. The Norman Church of St Dogfan is a Grade II listed building that was restored in the late thirteenth century. It dates back to the thirteenth century. In its churchyard there is a gravestone displaying a Celtic cross, thought to be of Cwgan, from the eleventh century.

William Salesbury published his Welsh New Testament in 1567. Morgan believed that the Old Testament also needed a contemporary translation. In the early 1580s he began translating the Old Testament into Welsh, and in 1588 he published the whole Bible, including a revision of Salesbury's work, in a Welsh style that was designed for the common people. He also created a new Book of Common Prayer, published in 1599.

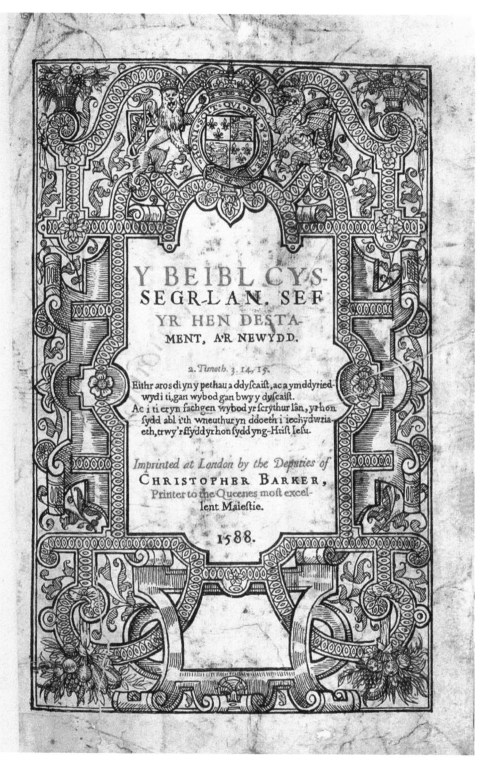

Y BEIBL CYS-
SEGR-LAN, SEF
YR HEN DESTA-
MENT, A'R NEWYDD.

2. *Timoth.* 3. 14, 15.

Eithr aros di yn y pethau a ddyfcaift, ac a ymddyried-
wydi ti, gan wybod gan bwy y dyfcaift.
Ac i ti er yn fachgen wybod yr fcrythur lân, yr hon
fydd abl i'th wneuthur yn ddoeth i iechydwria-
eth, trwy'r ffydd yr hon fydd yng-Hrift Iefu.

Imprinted at London by the Deputies of
CHRISTOPHER BARKER,
Printer to the Queenes moſt excel-
lent Maieſtie.

1588.

Morgan's bible.

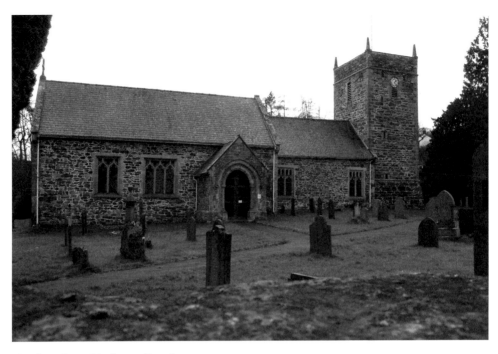

Llanrhaeadr-ym-Mochnant Church.

William Morgan was appointed Bishop of St Asaph in 1595 and lived in St Asaph before dying in September 1594.

He married twice, first to Ellen Salesbury before his time at Cambridge and later to Catherine. He had one son, Evan, who became vicar of Llanrhaeadr-ym-Mochnant.

He is memorialised at St John's Chapel, Cambridge, at St Dogfan's, Llanrhaeadr, and at the Translators' Memorial in front of St Asaph Cathedral.

9. Llanrhaeadr-ym-Mochnant Village

This is an unusual place. It seems like a village presenting itself as a town. It is isolated, at the near end of a long road of some 10 miles cutting into the Berwyn Mountains from the Morda Road, running south from Oswestry then turning westwards at the junction at Llynclys.

It has two squares. Its central square is edged with bold buildings, incorporating the larger-than-expected Wynnstay Hotel, a general store, newsagent's, butcher's, post office, and what used to be the Midland Bank, now a dentist's practice. The second square, smaller, leading to the church has charming stone cottages.

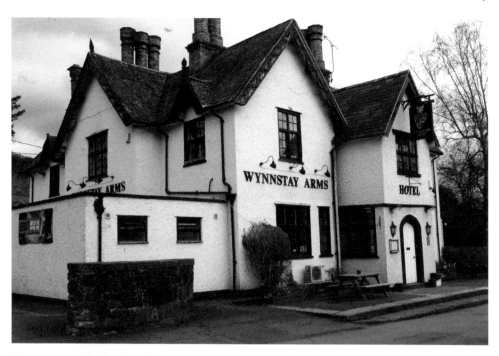

Wynnstay Hotel, Llanrhaeadr.

Llanrhaeadr-ym-Mochnant village centre.

It is named after the ancient Celtic commote of Mochnant (the 'stream of pigs'). It had, according to the 2001 census, a population of 1,470, of which 55 per cent were Welsh speaking. Until 1974 the border between Denbighshire and Montgomeryshire ran along the river, dividing the village, but in 1996 both parts were brought within the county of Powys. It is currently linked with Llansilin under an electoral ward.

10. Llanrhaeadr-ym-Mochnant Waterfall

In Welsh, this is a 'pistyll' ('waterfall'). It is formed by the River Disgynfa, falling over a Silurian cliff, in two main stages. From top to bottom it is 240 feet drop. It is sometimes described as Britain's tallest single-drop waterfall, but it is not a single drop. At its base, the river is the Afon Rhaeadr. It is one of the Seven Wonders of Wales in the old ditty, and it is a Site of Special Scientific Interest.

George Borrow visited it in the mid-nineteenth century, and writes in *Wild Wales*: 'What shall I liken it to? I scarcely know, unless it is to an immense skein of silk agitated

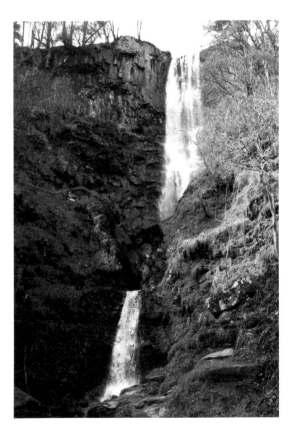

Waterfall, Llanrhaeadr.

and disturbed by tempestuous blasts, or to the long tail of a grey courser at furious speed. I never saw water falling so gracefully, so much like thin, beautiful threads as here.'

In 1774, as part of his grand tour of North Wales with Mrs Hester Thrale, Dr Samuel Johnson visited the waterfall. His main purpose was to call on his friend Dr Worthington, vicar of Llanrhaeadr. They stayed the night at the vicarage and enjoyed the waterfall. He reports that Worthington was responsible for creating the 4-mile road from the village to the waterfall. Hester 'was not disappointed at our entertainment, it is a glorious waterfall'.

11. Town of Whitchurch

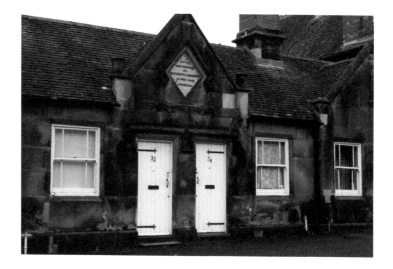

Whitchurch.

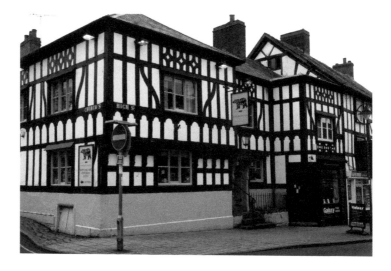

In the Dark Ages, when the Welsh border was farther to east than it is now, Whitchurch was part of the Welsh territory of Powys.

The Romans were here, and they called it Mediolanum because it was at a midpoint between Chester (Deva) and Wroxeter (Viraconium). Pepper Street has a Roman origin, deriving from Via Piperation, the street where pepper is sold.

Whitchurch has a population of 9,781. In 1066 Whitchurch was called Westune, located on the western edge of Shropshire. It has more than 100 listed buildings.

Whitchurch has been a centre for cheese production, and Thomas Telford's canal has been used for transporting the product. Clockmaking was also a feature of the town. J. B. Joyce were the first in the world to manufacture tower clocks and they are found across the world. The firm helped to build Big Ben in London.

Sir Edward German (1862–1936), composer, was born here in the building of the Old Town Hall Vaults and is buried locally.

12. St Almund's Parish Church, Whitchurch

This church was built in 1712 of red sandstone. Originally on this site was a Norman church. It is a Grade I listed building.

St Almund's Church.

13. Lloyd's Mansion, The Cross, Oswestry

DID YOU KNOW?
Lloyd's Mansion, The Cross, is one of Oswestry's oldest buildings.

The Lloyd Mansion at Cross Street, Oswestry, was built in 1604, after which it has had many uses. In the nineteenth century it was the site for the local branch of the Midland Bank. It is an impressive timber-framed building – the oldest in Oswestry. Originally it was the home of John Lloyd and family, housing their home above and a shop below. In 1875 it was renovated and restored.

Wilfred Owen's relative, Joseph Salter (1726–1800), lived and worked here as a watchmaker and general dealer. He is known as the town's first printer. His eldest son, Robert, wrote *The Modern Angler*.

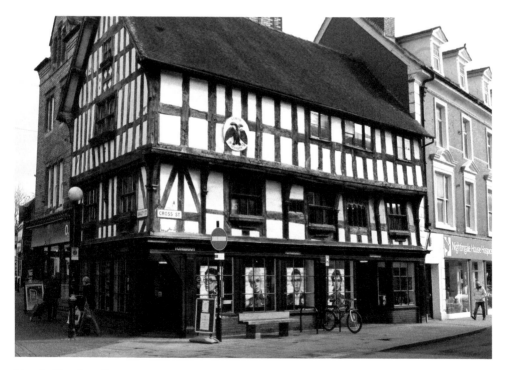

Lloyd's Mansion, Oswestry.

14. Whittington

This charming and historical parish had a population of 2,490 in the 2001 census and 2,592 in the 2011 census. The parish incorporates three smaller villages: Park Hall to the west, Hindford to the north-east and Babbinswood to the south. Whittington is part of the history of north-east Wales, originally called Trefwen ('white town'), the stronghold of Cynddylan, king of Pengwern.

In 1114 Henry I of England invaded Powys and granted Whittington to William Peverel. Whittington Castle dates from this period. It was then taken by the Welsh under Madog ap Maredudd, then taken back by Henry II. It was owned by Fulk III FitzWarin (d. 1258), whose coat of arms is seen above the archway. In 1253 it was owned by Llywelyn the Great.

There are two impressive gatehouse towers and built into the northern tower is a seventeenth-century stone cottage, which is Grade I listed. The castle was originally defended by a moat, of which two pools remain.

The popular White Lion public house, with ample parking, stands across the road.

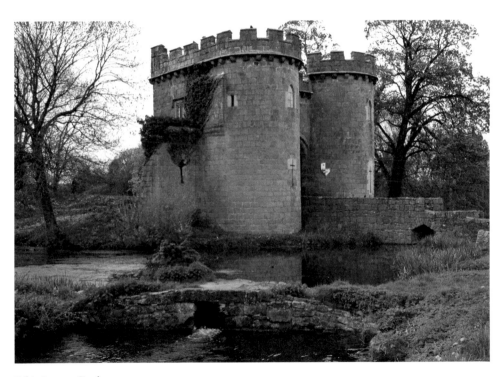

Whittington Castle.

15. Llanymynech Golf Course

DID YOU KNOW?
Llanymynech Golf Course is built on hills.

This course is truly extraordinary. One cannot image that across Europe there can be a more quirky and spectacular golf course. Founded in the 1930s, its creation must have been a tremendous effort. The full-size, eighteen-hole has multiple fairways and greens constructed between hills, around the high-point clubhouse, which is accessible at the end of a narrow road rising from the village of Pant, on the A483, after Morda and Llynclys, southwards from Oswestry. The rising, twisting road is single track and requires care in driving, especially with a wider vehicle.

Ian Woosnam OBE (Ryder Cup captain in 2006) writes in praise of this course, which is where he learned to play golf. Both his parents were captains here.

Offa's Dyke runs through the course, which is in both Wales and England. The tee for the fourth hole is in Wales, while the fifth and sixth holes are in England. The seventh tee is then in Wales!

Appropriately, the original name for the clubhouse is High Cottage.

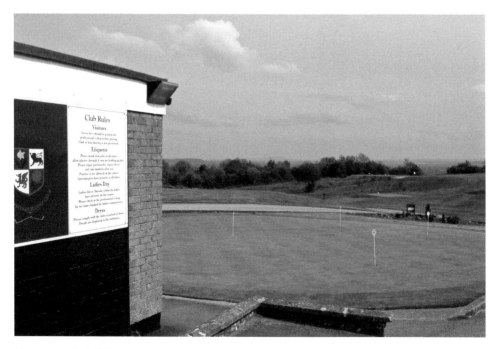

Llanymynech Golf Course.

16. Guto'r Glyn, Willow Street, Oswestry

DID YOU KNOW?
Guto'r Glyn, Welsh poet, lived in Willow Street.

A soldier of the fifteenth century (*c.* 1412–*c.* 1493), he was a poet writing in Welsh. The fact that he lived in Oswestry and spoke to his friends and neighbours in his native language is an indication of how much Welsh was spoken in Oswestry in the earlier periods.

Guto was a praise-poet, addressing his work to the nobility who were his patrons. He travelled widely in Wales, seeking accommodation and support. In 1441 he enlisted in the Wars of the Roses, fighting on the Yorkist side. He wrote poems in praise of Edward IV. However, after the Battle of Bosworth, he praised Welsh Lancastrian Rhys ap Thomas for killing Richard III: 'killed the boar, shaved his head'. It is thought that he originated from a farming family in the Ceiriog Valley. He spent his last years as a lay guest at the Cistercian Abbey of Valle Crucis, near Llangollen.

He and his wife had a wool-combing business at his home in Oswestry.

Here are some lines from Guto's poem in praise of Oswestry:

When I was young I was a man from the hill country
now, in old age,
it's natural for an old man to spend his life
in a noble town, that's where he lives..
There's a generous town to entice me,
the most gifted of all the towns,
the castle and the stone mantle
and the best town as far as Rome,
Oswestry, Jesus's beloved.
a town for the preachers,
and for poets and scholars...

Willow Street, Oswestry.

17. Trefonen

Trefonen, Treflach and Nantmawr are situated within 5 miles of Oswestry in present-day Shropshire. Offa's Dyke runs through them. They are located within the area designated Oswestry Uplands, in an Area of Special Landscape Character. Above Trefonen, the hill rises to 341 metres. The summit of Mynydd Myfyr gives wide views over the village.

The Barley Mow Inn, Trefonen, is at the centre of the village, a hub for socialising. In our picture locals are laying poppies in memory of the war dead.

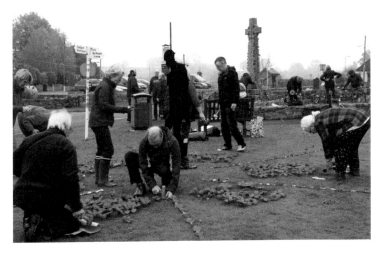

Trefonen.

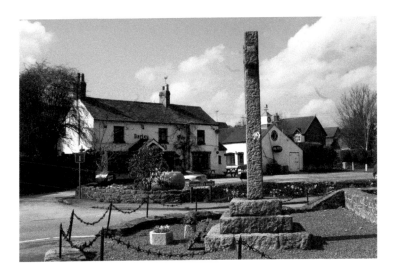

18. Oswestry School

DID YOU KNOW?
Oswestry School goes back to 1407.

This is a co-educational independent school for day pupils and boarders (aged fourteen
to eighteen). It presently has 440 pupils. It was founded in 1407 as a 'free school' – one

independent of the Church. This places it as the second oldest 'free school' in Britain. Winchester College dates back to 1382 and Eton College to 1440.

Known as 'the Grammar School', this school had a reputation for teaching the traditional subjects. Oswestry had another grammar school, state run, requiring an examination pass for entry: the present secondary school is The Marches School.

The school started on the site of the present half-timbered Information Centre, close to St Oswald's Parish Church, which has a café and exhibitions.

Oswestry School is at Upper Brook Street but the junior section is at Bellan House, a prominent building on Church Street. This was an independent preparatory school until its incorporation in the 1970s.

Oswestry School was founded by David Holbache, Member of Parliament for Shropshire and Shrewsbury, and his wife Guinevere. They were known by their Welsh names Dafydd ab Ieuan and Gwenhwyfar ferch Ieuan. The school's motto is '*Non scholae, sed vitae discimus*' ('We learn, not for school but for life'). Elizabeth I gave the school an endowment of 40 shillings per year to help with its costs.

It was for most of its existence a school for boys only. This brought about the establishment of Moreton Hall School (a few miles away in the Wrexham direction) in 1913, a girls' school. Girls were introduced into Oswestry School in 1972.

William Archibald Spooner, Thomas Mainwaring Penson, Ivor Roberts-Jones and John Godfrey Parry-Thomas are old pupils. Next to the site of the main school, part of its extensive playing fields is the battlefield where in AD 642 King Oswald was defeated by King Penda.

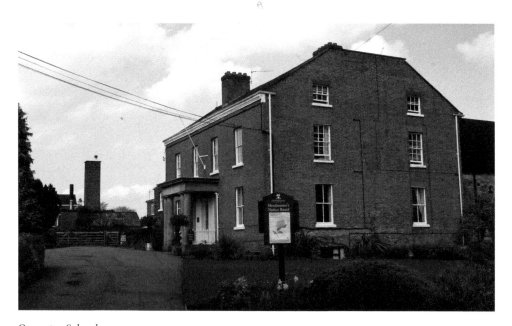

Oswestry School.

19. Llanfyllin

Granted a charter in 1293 by Edward I, this market town has charm and a maturity of buildings, shown by the use of native brick. Its church, dedicated to St Myllin, was founded in the seventh century. The present building is from 1706.

Its original motte-and-bailey castle was razed to the ground in a conflict of 1257. The earthworks are still present. Bodfach Hall, a Grade II listed building to the north-west of the town, dates from 1160.

The town lies in the valley of the River Cain in the Berwyn Mountains, 14 miles south-west of Oswestry. The River Abel joins it, flowing into the River Vyrnwy. The Union Workhouse, built in 1838, is an interesting Victorian building. It is presently being renovated and converted into a centre for local activities.

William Morgan (1545–1604), translator of the Bible into Welsh, was appointed Rector of Llanfyllin in 1579. He was later Bishop of Llandaff and St Asaph.

A local holy well, Ffynnon Coed y Llan, is dedicated to St Myllin. He is said to have baptised people there in the sixth century. It has a secondary school of reputation, drawing pupils from a wide area to the south-west of Oswestry.

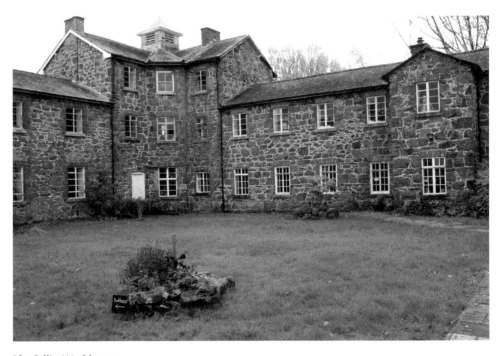

Llanfyllin Workhouse.

20. Ellesmere, the Mere, Castle and Town

DID YOU KNOW?
Ellesmere is in the Shropshire Lake District.

Ellesmere's lakes are called meres and attract many visitors. Its main mere has car parking spaces, a children's playground, a café, boat hiring and an assortment of wildlife.

There are nine meres catering for yachtsmen and fishermen. Geologically they are the product of glaciation, having no stream to flow, created by low-land drainage. These Shropshire meres are very rare geographically.

The most accessible meres are The Mere, Blakemere, Whitemere and Kettlemere, all of which are surrounded by dense wooded shorelines.

The Norman aristocracy covered Britain in new castles after the conquest in 1066. These were mostly of the motte-and-bailey type, built of earth and timber. The motte is a mound, which in Ellesmere is now on the site of the bowling green. Originally a 'donjon' – a large timber tower – would have dominated the site. This would have provided a lookout site

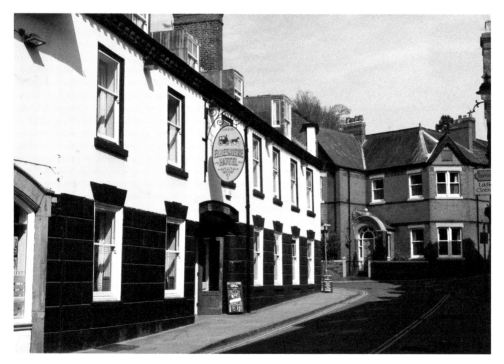

Ellesmere town.

Ellesmere mere.

and also accommodation for the chief lord. The bailey was an enclosure occupied by kitchens, stables and accommodation, where St Mary's Church now stands.

The castle was first created by Roger de Montgomerie, 1st Earl of Shrewsbury, after 1086. He was a Norman chief and close ally of William the Conquerer. In 1174 a Welsh prince took ownership of the castle after his marriage to Henry II's sister, Emma. It was owned by Homo le Strange in 1263, who held extensive land in northern Shropshire. It then passed by descent to the Stanleys, the Earls of Derby, prominent in Lancashire. John Leland visited in the sixteenth century. The top of the motte has been used as a bowling green since the eighteenth century.

21. Orthopaedic Hospital, Gobowen

It is no exaggeration to assert that this medical facility has left its healing mark across the world. It is recognised as one of the foremost specialist establishments in the world of medicine, specialising in orthopaedic treatment and surgery. It also has a reputation for innovation, providing musculoskeletal (bone, joint and tissue) treatment.

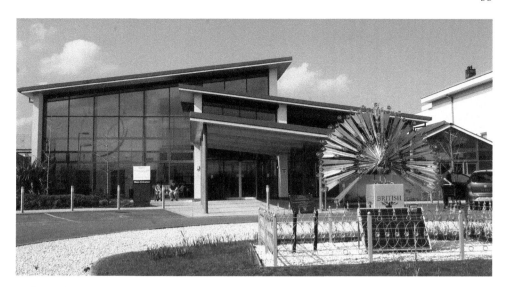

Orthopaedic Hospital, Gobowen.

The Robert Jones and Agnes Hunt Orthopaedic National Health Service Foundation Trust occupies a site close to Oswestry and the Welsh border, on the English side. It is part of the UK state health service, a free service.

The hospital has nine inpatient wards, including a private ward, and ten operating theatres, as well as extensive outpatient and diagnostic facilities.

It started in Baschurch as a children's hospital under Miss Agnes Hunt. It then became an independent hospital in 1900 and occupied its present site in 1921. It became part of the NHS in 1948 and became a trust in 1994. It was awarded NHS Trust status in 2011.

In 2008–11 a specialist team of researchers at Imperial College London discovered that the risk of death was 44 per cent higher if an operation took place on a Friday in a standard medical facility. However, in comparison, around 10,000 procedures are carried out at Gobowen and 2000–12 recorded thirty-three deaths after operations.

In 2015 it was recorded as one of the top NHS trusts to work for. At this time it had 1,101 equivalent full-time staff and a sickness absence rate of only 3.2 per cent. 71 per cent of staff recommended it as a good place to work.

22. Wilfred Owen, Plas Wilmot

Born on 18 March 1893 in Oswestry, Wilfred Owen died on 4 November 1918 at the Sambre – Oise Canal, Ors.

His poems were written in a little over a year, from August 1917 to September 1918. Only five of his poems were published in his lifetime.

Plas Wilmot.

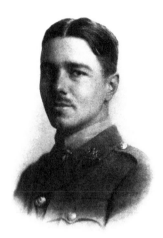

Wilfred Owen.

Wilfred was brought up in Oswestry, Birkenhead and Shrewsbury. In 1913–15 he was teaching in France, where he worked on the rhyming patterns that became characteristic of his poetry.

He enlisted in the British Army in 1915. In early 1917 he was affected by shell shock and returned to England for treatment. He was at the Craiglockhart Hospital in Edinburgh where he met Siegfried Sassoon, also from the war, who encouraged him in his writing.

Owen returned to the Western Front where he took part in breaking the Hindenburg Line at Joncourt, for which he was awarded the Military Cross.

Owen's reputation as a poet has grown steadily. In 1931 Edmund Blunden published an influential biography and Benjamin Britten's *War Requiem* included a number of his poems. Dylan Thomas wrote, 'It is the preface, by Wilfred Owen, to a volume of his poems which was to show, to England, and the intolerant world, the foolishness, unnaturalness, horror, inhumanity and insupportability of war.'

He wrote one of the finest sonnets ever written in English – 'Anthem for Doomed Youth' – which begins 'What passing-bells for those who die as cattle?'

23. The Black Gate

At No. 7 Salop Road, this is one of Oswestry's most distinctive buildings of Tudor origin. It is Grade II listed with a wood-panelled interior.

August 2017 saw the reopening of this establishment after improvements and refurbishments. It is one of the old taverns of the town. Originally a house erected in 1600, in the Victorian era it was closed by the temperance movement and became a tearoom until the 1960s.

It is close to the Leg Street traffic island and the former Regent Cinema. Until the 1930s this was the site of the Dorsett Owen Brewery, which was closed following their merger with Wrexham's Border Brewery.

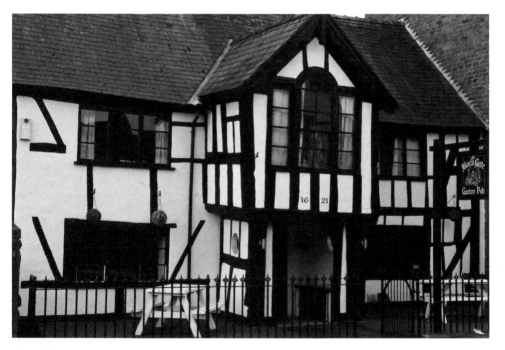

The Black Gate.

24. Victorian Railway Buildings

Motoring into Owestry from the east and giving a nod to our ancestors on the hill fort to the north, the entrance to Oswestry town is architecturally disappointing. That is until we observe the old railway building in Oswald Road on the left, opposite the supermarket car park. And then, after it around to the left, we see the magnificent façade of the old railway engineering works building. These two structures are among Oswestry's Victorian gems.

Opened in 1860 and designed by Benjamin Piercy, this distinctive brown-and-cream building of the original station was the headquarters of the Cambrian Railway. The single-platform railway originally started with single-track operation in 1849 under Great Western Railways (GWR). It closed to passengers in 1966, although a steam service began in 2014. The present building, which has been well preserved, was designed to include

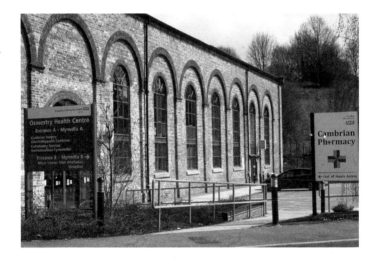

Victorian railway building, Oswestry.

offices and a boardroom overlooking the tracks. It has strong architraves, full cornices, quoins and bay windows.

Designed by John Robinson in 1866, the second building, the spectacular engine shed, was expanded in 1929 with new inspection pits. In 1946 the British railway system was nationalised under British Railways. This building was closed for railway use in 1965.

Originated as a locomotive, carriage and wagon building in 1866, this is a spacious brick building of some 750 feet long. Inside there was originally a space for engineering and a smithy. There is also a 150-foot chimney.

The engine shed has an elegant row of windows headed by curved brickwork. It has ample car parking and is used mostly for medical purposes. The station's former goods depot now serves as the Cambrian Railways Museum. Heritage trains operate in Oswestry and Llynclys at weekends and public holidays from April to October.

Fifty-three Cambrian Railways employees died in the First World War. A memorial to them can be seen in Cae Glas Park.

25. Cae Glas Park

This beautiful, well-cared-for space is a prominent feature of the centre of Oswestry town. With a fine entrance and tall gates on Church Street, its flower displays are a credit to municipal gardeners. The expansive area has a sports village, a bowling green, children's play area, a traditional bandstand, with music, tennis and bowling competitions. Crazy golf is available on payment of a fee.

The site originally held Cae Glas Mansion, mentioned in 1791, with 'pillared entrance, railings and four gates' centred on Church Street. The property in the seventeenth century formed part of the estate of the Kynastons of Maesbury, who are listed as owners of the site in 1707.

In 1908 Mr Charles Jones of Rossett offered the land for sale to the town council, to be converted to a public park, with properties in Church Street for £6,000, and he was offering to contribute £200 for the layout of the grounds. This generous offer was accepted and the park created for public use. It was opened in 1910.

The sale was agreed on the condition that the Corporation would not use Cae Glas 'for any purpose whatsoever other than a public walk or pleasure ground'. A bowling green was added in 1932 and further purchases were made in 1951 and 52.

Oswestry Town Council administers the park, which received a Heritage Lottery Award of £283,800 in 1998 to facilitate major improvements.

The year 2006 saw the opening of the Sports Village, with facilities for floodlit tennis and five-a-side football, cricket (wicket and cage), basketball and netball.

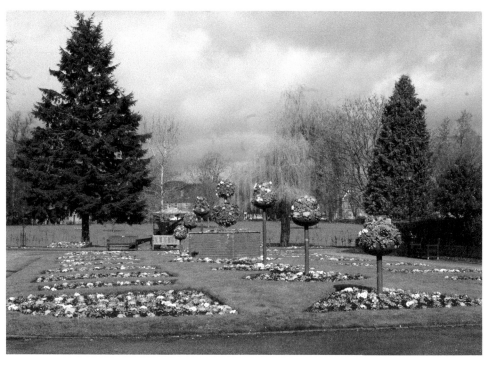

Cae Glas Park, Oswestry.

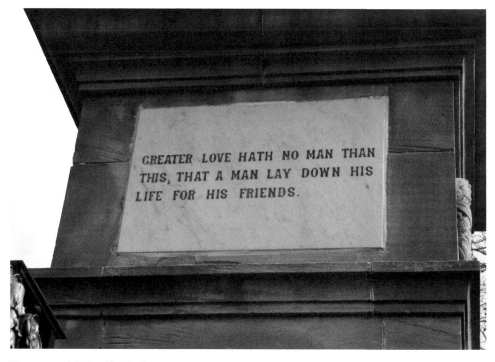

War memorial, Cae Glas Park.

26. The White Lion, Llynclys

A public house at a crossroads to the south-west of Oswestry, the White Lion marks the site where a traveller can turn towards Llanfyllin and the Tanat Valley, where Llanrhaeadr-ym-Mochnant is much visited by explorers and walkers seeking the much-admired waterfall.

A tradition of good food continues here. The pub was once a stopping point for drovers, men who took live animals from North Wales to the markets eastwards, to Oswestry, Shrewsbury and sometimes as far as London. Their accommodation at inns would be adjacent to space for their animals.

White Lion, Llynclys.

27. Sweeney Hall

This impressive building, to the south of Oswestry dates back to 1563 when it was owned by Henry FitzAlan, Earl of Arundel. In 1640 a new house was built: 'A new fair house in Sweeney, a handsome pile of buildings'. Thomas Baker, the owner, was High Sheriff of Shropshire.

In October 1649, Norry, King of Arms, designed an insignia of three swans' heads with another head held aloft. The name designates this local area. The grounds include a graveyard for Nonconformists buried there in the seventeenth century. A family motto, 'Dead Shame', is carved above the front door.

The Sweeney Hall Hotel has been owned by the Evans family since 1993. New bedrooms have been created according to the style of the original house.

In the sunny summer months, the outside garden plots are occupied by diners, many coming in organised groups from Welsh areas to the west, such as Llanyblodwel.

Sweeney Hall, Oswestry.

28. Ellesmere College

DID YOU KNOW?
Ellesmere College was founded in 1879.

Founded by Canon Nathaniel Woodand with a motto '*Pro Patria Dimicans*' ('Strive for one's country'), this independent co-educational school with pupils aged from seven to eighteen currently has 615 pupils.

It is situated in a beautiful rural site at the outskirts of Ellesmere, of some 114 acres, with views to the Breidden Hills. The land was provided by Lord Brownlow and the place was originally called St Oswald's School. It is Anglo-Catholic in religion. In 1966 a catastrophic fire destroyed the chapel and dining hall. They were rebuilt soon after, with new classroom buildings added through the 1970s.

The sixth form offers the International Baccalaureate Diploma and BTEC level 3 National Diploma in Sport as well as A-levels.

There are two houses for sixth form boys – St Bede's and St Luke's – and one for girls – St Oswald's. Pupils have a choice of being full boarders, weekly boarders or day pupils. Presently there are 187 boarders with 140 in the sixth form.

Old Ellesmerians include Bill Beaumont, rugby player; Peter Jones, actor; Michael Howard, musician; and Hugh Grosvenor, 7th Duke of Westminster.

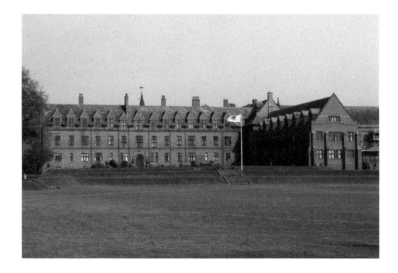

Ellesmere College.

29. Oswestry Cricket Club

Founded in 1855, the club occupies an attractive site on Morfa Road. It sits in the Birmingham and District Premier League and is currently seventh in the third division. In 2005 it had a celebration match against the Marylebone Cricket Club (the renowned MCC). There are four matches played on Saturdays through the cricket season – one at home; in addition, there are junior games.

Originally at Victoria Road, the club moved to its present location in 1947. The pavilion was the former canteen at the Coventry Climax factory before it was replaced, at a cost of £35,000, in 2005–06.

Andy Lloyd, an Oswestry player, became captain of Warwickshire and also played for England. Many locals have represented Shropshire at minor counties level.

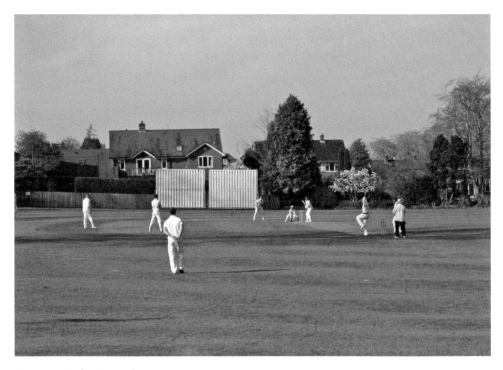

Oswestry Cricket Ground.

30. Stonehouse Brewery, Morda

Situated next to the Cambrian Railway at Morda, this is a fully functioning brewery, located behind the industrial estate. They bring in wheat, etc., and engage in their own brewing. They have 'Wheet Beer', 'Cambrian Gold' and 'Station Bitter'. There are cask beers and keg including a Pilsner and a Witbier. Gin and whiskey are also available.

Their café does not serve full hot meals but they do use their own wood-fired oven for pizzas on Fridays and Saturdays from 4 to 7 p.m. The brewing process can be seen from the café. Outside there are chairs and picnic tables.

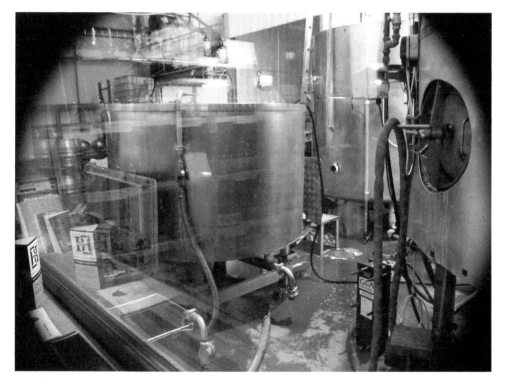

Stonehouse Brewery, Oswestry.

31. Ian Woosnam OBE

DID YOU KNOW?
Ian Woosnam OBE, golfer, had world-record earnings in 1987.

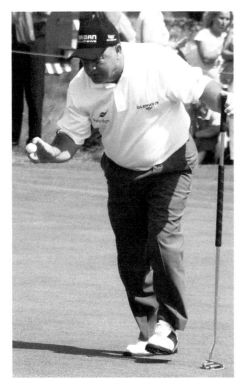

Golfer Ian Woosnam. (Courtesy of Steven Withers under Creative Commons 2.0)

Born in March 1958, nicknamed 'Woosie', Woosnam was one of five major European golfers who were born within a year of one another. The others were Seve Ballesteros, Nick Faldo, Bernhard Langer and Sandy Lyle. The last named was from north Shropshire and the two played on the same courses. Ian is a short man, measuring 5 feet 4.5 inches and weighing 12 stone. He presently resides in Jersey in the Channel Islands.

He grew up in St Martin's, where his parents lived. He started playing at the unique Llanymynech Golf Club. It is said that he developed the hitting power in his torso by carrying bales on his parent's farm. As an amateur, he played at regional competitions in Shropshire.

His career as a professional player started in 1982 when he won the Swiss Open and came eighth in the Order of Merit prize list. In 1987 he set a world record for top earnings of over a £1 million in one year. In 1991–92 he won the Masters.

In the Open in 2001 there was an incident involving the wrong number of clubs in his bag. He took a very sportsmanlike attitude and did not fire his caddy. At the age of forty-three he became the oldest player to win the World Match Play Championship.

He was part of the Ryder Cup team eight consecutive times, from 1983 to 1997. He was elected captain for 2002 and later for 2006, leading Europe to victory over the USA.

He was awarded an OBE in the 2007 New Years Honours List and was inducted into the Golf Hall of Fame in 2017.

32. The Wynnstay Hotel, Oswestry

At No. 43 Church Street, Oswestry, this spacious coaching inn, opposite the church, is an impressive building with parking at the rear. It has thirty-four bedrooms, a function room and the Four Seasons restaurant. The building is Georgian and four-star rated. It has served at the centre of Oswestry's accommodation and eating house history for hundreds of years. There is a fitness centre incorporating a heated pool, gym, bowling green and jacuzzi in the old stable block.

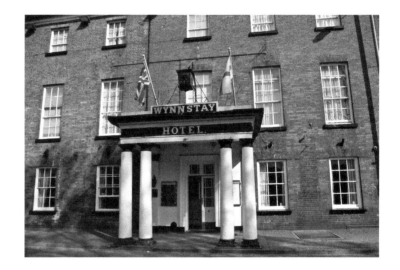

Wynnstay Hotel, Oswestry.

33. Sir Robert Jones

Sir Robert Jones, 1st Baronet (1857–1914), was a Welsh orthopaedic surgeon who was an early user of radiography. He was born in Llandudno, then moved to London and Liverpool, where he attended the Liverpool School of Medicine. He worked in the Stanley Hospital in Liverpool. He received his FRCS in 1889.

In 1888 he was appointed Surgeon-Superintendent for the construction of the Manchester Ship Canal, responsible for the injuries of 20,000 workers. He established the world's first accident service.

X-rays were brought into prominence in 1895 and Jones was one of the first to use them. He played a major part in administering medicine during the First World War. He improved the treatment of fractures, with responsibility for 30,000 beds.

Surgeon Sir Robert Jones.

He received honorary degrees from six universities. He was awarded the USA Distinguished Service Medal in 1919. The Robert Jones and Agnes Hunt Orthopaedic Hospital at Gobowen is named after him.

34. Sebastians, Willow Street, Oswestry

A feature building of central Oswestry over the last twenty years, Sebastians was originally from the seventeenth century, incorporating three cottages. Its culinary style is French, five-course meals are available and group dining is a feature.

There are six bedrooms including balconies. There is a garden and a small yard at the rear.

Sebastions, Willow Street, Oswestry.

35. Castle Mound, Oswestry

DID YOU KNOW?
Oswestry Castle started in the eleventh century.

There are motte-and-bailey castle remains in this Scheduled Monument and listed building. The surviving Norman castle motte (mound) takes a prominent position in the centre of the town. The motte is late eleventh century and the remains of the castle are thirteenth century. Only fragments of the medieval structure survive: two pieces of collapsed masonry and the remains of a bastion on the east side. There are also remains from the twelfth-century keep. The castle was erected by Madog ap Meredydd sometime before 1159. A document of 1398 lists its sections and rooms.

In 1398 a parliament was held here by Richard II. Royalist and Parliamentary forces attacked the castle during the Civil War.

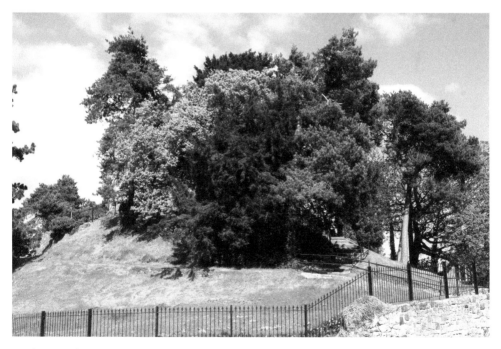

Castle Mound, Oswestry.

36. Ironworks Centre

Situated on the main road south of Oswestry towards Shrewsbury, this centre is dedicated to metalwork and craftwork. There is a metal safari park, with over 100 different animals and species, including the silverback gorilla.

In 2013 the centre was asked to produce four pavilions in iron to celebrate the anniversary of Elizabeth I's coronation. They were erected in the gardens of Buckingham Palace. In April 2016 thousands of metal flowers were created as a fundraiser.

In 2013 the illusionist Uri Geller commissioned the centre to create a 12-foot-high gorilla made from spoons sent in from all parts of the globe. Over 40,000 spoons were received. The sculpture was created by Alfie Bradley over five months.

Ironworks Centre.

37. Wilfred Owen Green, Oswestry

This is a 5-acre site in the centre of Oswestry, adjacent to the railway station and museum. It was previously derelict land that was granted village green status in 2008. With a budget of £170,000 Shropshire Council's Conservation and Community Officer was able to create this new park. Meadows, woodland and green spaces of formal design, including a labyrinth, allow for a relaxing site, with children's play items. A small orchard is included, along with a wildflower meadow and woodland. Birds of a variety are pleased to use it.

It has footpaths and seats and a small arboretum containing some unusual specimens. Wat's Dyke runs through here.

Wilfred Owen Green was formally opened by Peter Owen, Wilfred Owen's nephew, in 2010.

Wilfred Owen Green, Oswestry.

38. Willow Gallery, Oswestry

A much-praised home for contemporary art with an emphasis on the local, spacious and relaxing, artists are invited to work here. Artworks are generously displayed and exhibitions are held regularly on a particular theme. A café adjoins. During my visit, I spoke in Welsh to two older ladies. I asked where they lived and they replied Croesoswallt, confirming the presence of Welsh speakers in the town. They were supporters of the local Methodist Welsh chapel.

Willow Gallery, Oswestry.

39. St Oswald's Well, Oswestry

Deriving from the Battle of Maserfield, this holy well, according to legend, sprang where a limb of King Oswald was dropped by an eagle. It is approached from Upper Brook Street. The well is supplied by a spring flowing from the elevated ground behind it. Its water is believed to be a cure for weak eyesight and legs.

It was first mentioned in a fourteenth-century document. There was a chapel on this site, mentioned by Pennant.

William Cathrall, in his book on Oswestry, is enthusiastic about this site. He writes: 'we would recommend all visitors to Oswestry make a pilgrimage to Oswald's Well. The scenery around it is replete with beauty: and if the day is fine and warm, a draught of the water, which constantly bubbles up in freshness and pellucid clearness, will cheer and not inebriate. The inhabitants possess in this well a valuable natural treasure which it is heir duty to preserve, for their common benefit, free from all impurities and contaminations.'

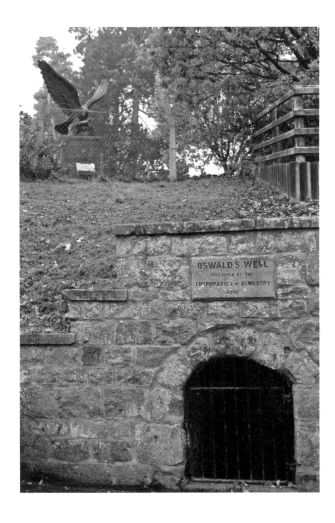

St Oswald's Well, Oswestry.

40. Moreton Hall School

This is an independent school for girls aged three to eighteen and boys aged three to eleven. It is located at Western Rhyn, 4 miles from Oswestry in north Shropshire. It was established in 1913 and has seventy staff and around 460 pupils.

The original founder of the school, Ellen Augusta Crawley Lloyd-Williams, died in 1940, having established a school with a reputation for public performance, music and dance. The educational trust expanded, with new buildings and a swimming pool. The school is set in 100 acres of parkland, offering a range of sporting facilities. There are six boarding houses and most pupils are boarders.

Lacrosse and hockey are the principal winter sports, and there are many outdoor tennis courts. Pupils taking track events have an opportunity to train at a track in Wrexham.

Public speaking is taught, as is drama and debating. Moreton Enterprises has been established to enable pupils to have experience of business.

Old pupils include Kyffin Williams, painter; Alison Rylands, artist; and Zanny Beddoes, editor of *The Economist*.

Moreton Hall.

41. Park Hall and Mensa

On the B4579, Park Hall is described in reviews as 'a great day out for young families ... the animals are very well looked after.'

The site is very old, going back to 1563 when it was part of the lands of Whittington Castle. In the sixteenth century a large house, Park Hall, was built by Thomas Powell.

In 1914 the Army took over Park Hall as an officers' mess, and the land became an army camp. The entertainment side of the army, called Mensa, put on many shows here. In 1918 the hall burned down. In the 1990s the site was designed as a visitor attraction, including The Trenches Experience, the Welsh Guards Collection and the Victorian School. Alpacas and goats are housed, and in the spring the birthing of lambs can be witnessed.

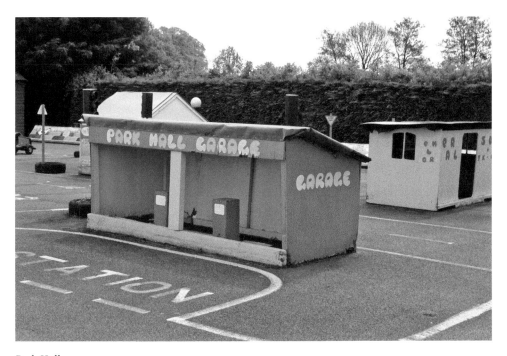

Park Hall.

42. The Cambrian Heritage Railway and Museum, Oswestry

This is located at Oswald Road. In the summer, trains run on the old line down to Llynclys, some of which are steam driven. They run every thirty minutes between 11 a.m. and 3.15 p.m.

The museum has many interesting artefacts. Run by the Cambrian Railways Society, it has collected many valuable items. These come from the Cambrian Railway Company, which covered large areas of Mid and North Wales. The last remaining CR goods shed houses the museum. The original south signal box has been restored and is now an educational facility. The steam locomotive *Oliver Veltom* is currently under overhaul. The society is working on reopening a section of the Tanat Valley Railway from Llynclys Junction to Blodwell and up the Nantmawr Branch.

Cambrian Heritage Railway, Oswestry.

43. Baschurch

Connected by history to Oswestry and north of Shrewsbury, this is a large village with a population of over 2,500.

The Welsh background is revealed in a poem of the ninth century called 'Eglwysau Bassa'. An English translation of the beginning reads:

Baschurch is his resting place tonight,
His final abode –
The support in battle,
The heart of the men of Argoed...

This poem points to the slaying of the welsh chief Cynddylan in battle.

The world's first orthopaedic hospital was established at Florence House in Baschurch by Sir Robert Jones and Dame Agnes Hunt in the 1900, treating crippled children and the wounded in the First World War. It moved to Gobowen in 1921.

Welsh chieftains and kings are buried in Baschurch, including, it is said, King Arthur. An ancient fort/earthwork exists in the countryside outside Baschurch.

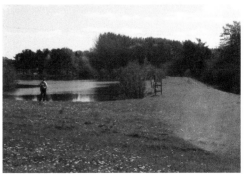

Baschurch.

44. Ruyton XI Towns

DID YOU KNOW?
The name originated in the twelfth century with a manor of twelve townships.

An extraordinary name, it was formerly Ruyton of the Eleven Towns. It lies on the River Perry and has a population of around 1,500. Baschurch is to the east. The name derived from the twelfth century when a castle was built and it became the manor of eleven townships. The Roman numeral for eleven is included in its name. Some of the ancient townships exist today, although some as merely a group of houses. The castle was destroyed by Owain Glyndwr in the early fifteenth century. The parish church dates from the 1130s. Arthur Conan Doyle, a medical student, worked in 1878 as an assistant to a local doctor, living at Cliffe House. He wrote in his *Memories and Recollections* (1923) that Ruyton was 'not big enough to make one town, far less eleven'.

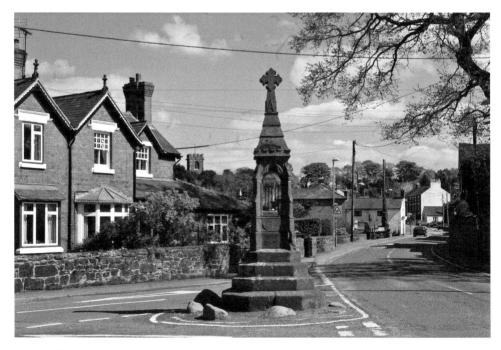

Ruyton XI town.

45. Sycharth, Owain Glyndwr's Home

Sycharth is a motte-and-bailey castle in Llansilin, Powys. It was the birthplace of Owain Glyndwr and sits in the valley of the River Cynllaith, a tributary of the Tanat.

The site is about a kilometre to the west of the Wales–England border. The B4580 passes near the site, which is accessible along a minor road. It is to the south-west of Oswestry and to the south of Llansilin. The Welsh preservation group CADW is in charge of the site, which has an information board on display.

The Welsh Kingdom of Powys Fadog originally covered this site. Following the Norman Conquest, this castle was built by the Normans. The Domesday Book indicated that this took place before 1066. Owain Glyndwr inherited Sycharth in 1369 and lived here with his wife Margaret Hanmer and their children.

Iolo Goch said of the house, 'nine plated buildings on the scale of eighteen mansions, fair wooden buildings on the top of a green hill ... tiled, with a frowning forehead, and a chimney from which the smoke would grow; nine symmetrical, identical halls, and nine wardrobes by each one...'

Archaeological results from the early 1960s revealed the presence of two timber halls on the flat-topped mound, one 43 metres in length. There was evidence of burning, which was carried out by Harry of Monmouth, later Henry V, who had the site destroyed in May 1403.

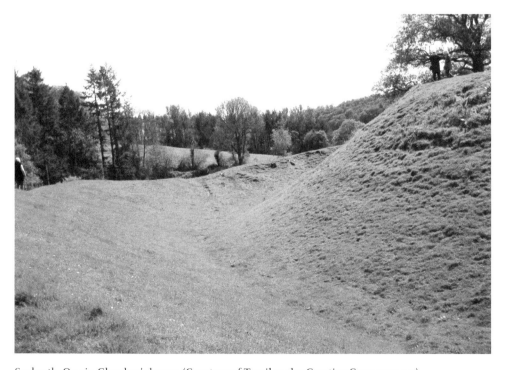

Sycharth, Owain Glyndwr's home. (Courtesy of Tyssil under Creative Commons 3.0)

46. Wem and Sweet Peas

DID YOU KNOW?
Wem is the home of Sweet Peas.

To the east of Oswestry, Wem is an old community originally settled by the Cornovii, an Iron Age tribe, before the Roman settlement. The town is recorded in the Domesday Book as having four manors in the Hundred of Hodnet. The River Roden flows to the south of the town. From 1202 it was a market town. A Lord Wem is indicated as William Pantulf. The town was involved in the English Civil War, supporting the Parliamentarians. The present population is in the region of 5,100.

Its peculiar reputation for sweet peas is because the plant was first commercially cultivated here, with a variety named Eckford Sweet Pea, which was grown by nursery man Henry Eckford, Fellow of the Royal Horticultural Society. This started in 1882 and he went on to create more new varieties. There is an Eckford Park in Wem, celebrating this success. Each year, in July, the Eckford Sweet Pea Festival is held in the town.

The old brewery in Noble Street was responsible for a considerable output of beer but this closed in 1988.

Judge Jeffreys (1645–89) had his home here in Lowe Hall; he was made Baron Jeffreys of Wem. William Hazlitt (1778–1830), essayist and critic, grew up here. His father was an Unitarian minister. He later lived in London. Greg Davies (b. 1968), comedian and actor, was brought up in Wem.

47. Llanymynech

DID YOU KNOW?
The English–Welsh border runs down High Street.

Sited on the border between Powys and Shropshire, Llanymynech has a population of near 1,600. The Welsh name translates as 'Church of the Monks'. The River Vyrnwy flows beside it and the Montgomery Canal passes through it.

The town's distinction is that it is split between two countries – Wales and England – and two counties – Powys and Shropshire. The border runs down the main street, with

Llanymynech.

the eastern part in England and the western part in Wales. On the edge of the town, on the main road leading to Oswestry, there is a sign reading 'Welcome to England'. The Church of England parish church, dedicated to St Agatha, is in England.

When alcohol drinking was banned in Wales on a Sunday, the pubs in this village became 'wet' or 'dry'. Of the three pubs remaining now, two are in England, with one in Wales. Just to the north of the village is Pant, then afterwards to the north is Oswestry.

Llanymynech Hill is an old site for copper mining, which dates back to the Bronze Age. Here there is a hill fort, probably used as accommodation for copper miners. First- and second-century Roman coins were found here, and lead and zinc ores have been mined here. A rare Hoffman Kiln remains as part of the process of creating lime as fertiliser. With its tall chimney, it worked until 1913 when the quarries closed. Tramways were built to the quarries.

Offa's Dyke was built through the main road, on the east side; the east wall of the churchyard is seemingly built on the mound.

St Agatha's Church was designed in the 1840s by Thomas Penson of Oswestry.

48. The Old Midland Bank, Central Oswestry

On the corner of Church and Willow Street (The Cross), this is a striking building built in 1890. Designed by Grayson and Ould, it is neo-Tudor in design, in red brick with ashlar dressings. This building displayed wealth in the Victorian period, and the Midland Bank was prominent and prosperous. It was founded in Birmingham in the 1830s. The Midland Bank was taken over by the HSBC Bank.

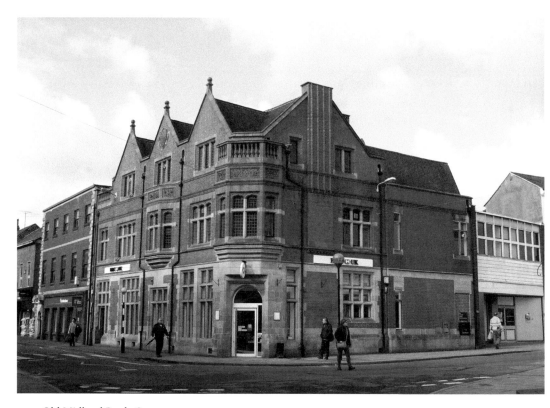

Old Midland Bank, Oswestry.

49. Offa's Dyke

This extraordinary landscape feature is some 170 miles long and follows the Wales–England border. It is named after King Offa, the Anglo-Saxon king of Mercia. Built from AD 757 until 796, to its west was the Welsh kingdom of Powys. Other research places the construction of this dyke as early as the fifth and sixth centuries.

In places it is 65 feet wide and 8 feet high, running over hills and rivers. The protected Offa's Dyke Path runs from Liverpool Bay in the north to the Severn Bay in the south. It has a ditch on the Welsh side, suggesting it is a defensive position for the Mercians, who could observe landscape from its ridge. Where the ditch encounters a natural feature such as hills and woods, the feature runs to the west of them. The dyke runs north–south close to Wrexham, Chirk and Oswestry.

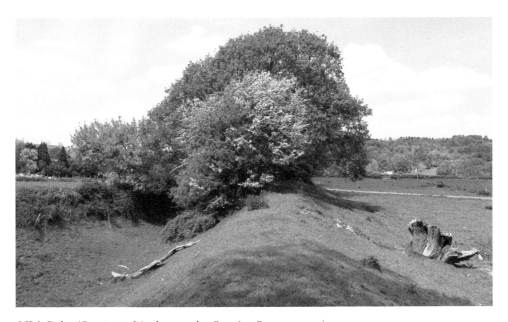

Offa's Dyke. (Courtesy of Andrew under Creative Commons 2.0)

50. Oswestry's Old Grammar School

This is a fifteenth-century, Grade II listed, timber-framed building. It occupies a prominent position close to St Oswald's Church. Originally the grammar school, it was founded by David Holbache in 1407. It is now a café and information centre and has a bold lychgate.

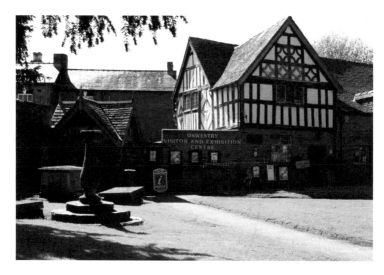

Old Grammar School,
Oswestry.

51. Lion Quays

This site is opposite Moreton Hall School. Situated on the Llangollen Canal, this large hotel offers good accommodation and dining. It also has a spa.

Lion Quays.

52. Oswestry – a Mecca for Golf

The Llanymynech Course was the home of the Oswestry Golf Club from 1903 to 1931. To the south, on the Shrewsbury road, is Aston Park and this was where James Braid recommended that Oswestry Golf Club should resettle. He was a respected course designer, having created Carnoustie, Gleneagles and Royal Blackheath.

When the new course was opened, Henry Cotton, champion in 1934, 1937 and 1948, said it was one of the best courses he had played on, praising the design of the twelfth hole. The course is created on sandy soil so is capable of quick drainage, making it playable in wet weather. Oswestry had Harry Weetman and Ian Woosnam as regular members. More recently, Scott Drummond, 2004 European PGA winner, spent his early years playing on this course.

Full catering is offered, there is a lounge, bar and dining room and a professional who offers golf lessons. Buggies are available for hire.

The Mile End course is located closer to Oswestry. Another full-size course, it is also located on attractive parkland.

Ian Woosnam, one of the outstanding players of British golf, played on both courses and many stories are told of his extraordinary distance hitting, despite his small stature.

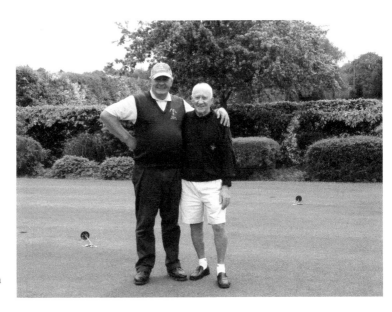

Oswestry – a Mecca for golf.

53. St Oswald's Church, Oswestry

DID YOU KNOW?
St Oswald's Church is over 900 years old.

An impressive church at the heart of Oswestry, it is dedicated to St Oswald, who was killed in the Battle of Maserfield, which took place some 400 metres from this site. In around 1530 John Leyland writes that 'the church was once a monastery called The White Minister' but there is little known about the time of the monks.

The twelfth century saw many attacks on the town and church, and there is evidence of thirteenth-century building work. In 1599 William Morgan, who translated the whole Bible into Welsh, was appointed vicar of Oswestry. The church was badly damaged during the Civil War and used as stables by the Parliamentarians. In the 1670s a new building was created.

The interior Yale Memorial of 1616 celebrates Alderman Hugh Yale, whose family endowed Yale university in the USA.

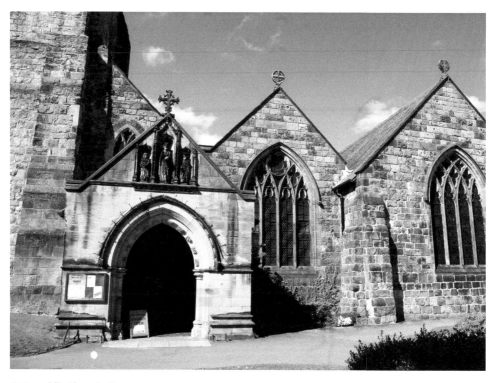

St Oswald's Church, Oswestry.

54. T. Jones & Son, Saddlers

A Leg Street retailing phenomenon and the second oldest business in Oswestry, it was started by Thomas Jones, grandfather of the present owner, David Jones, in 1893. He was eighty-five when he passed away.

Despite the Internet, it flourishes, attracting customers from all over the north-west of England and the Welsh hinterland. Leather repairs are a speciality. It stocks belts, purses, wallets, handbags, jodhpurs, all in a traditional style. Saddles are brought in for repair.

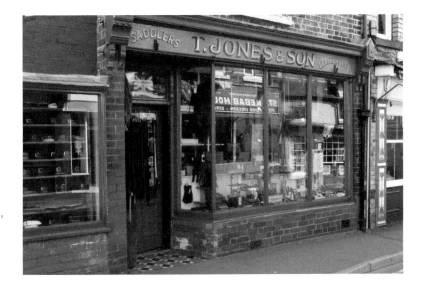

T. Jones & Sons, saddlers, the second oldest business in Oswestry.

55. Llanyblodwel

Six miles south of Oswestry, situated in the valley of the River Tanat and accessible from Llynclys, Llanyblodwel has a population of around 800. The Church of St Michael the Archangel is located down a lane, built on a shelf over fields. Its spire is peculiar, being a rounded shape, which was created by Victorian vicar John Parker. The name is a mixture of '*llan*' translating as 'church' or 'parish' and '*Blodwell*', meaning 'tributary of the Tanat'.

The Horseshoe Inn is a striking late medieval half-timbered building next to an ancient bridge over the Tanat.

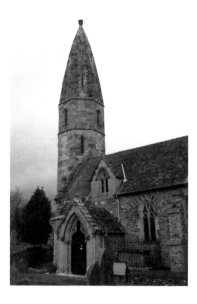

Llanyblodwel Church.

56. The Ceiriog Valley

This is the valley of the River Ceiriog. It opens out westwards from Chirk, the country road, the B450, twisting and turning until it comes to an end at Llanarmon Dyffryn Ceiriog, around 12 miles from Chirk. This valley is part of the County Borough of Wrexham and is traditionally Welsh speaking.

It was described by the then British Prime Minister David Lloyd George as 'a little bit of heaven on earth'. Glyn Ceiriog is the largest village here, followed by Llanarmon Dyffryn Ceiriog, Tregeiriog, Nantyr, Pandy and Pontfadog.

The Welsh poet John Ceiriog Hughes (1832–87) was born in a farm near Llanarmon-D-C.

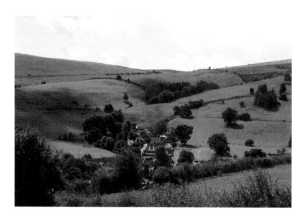

The Ceiriog Valley.

57. The Hand and the West Arms at Llanarmon

There is a distinctiveness about these two publics houses. The Hand had a particular specialism in catering for those fishing for trout in the nearby River Ceiriog. They have been turned into sophisticated hostelries, both catering at a high standard for visitors. The Berwyn Mountains surround this village and walkers are frequent visitors. The largest waterfall in Britain is situated north of Llanrhaeadr-ym-Mochnant, to the west of Llanarmon along a mountain road.

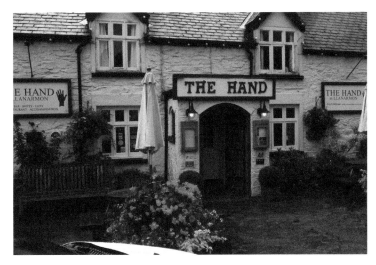

The Hand, Llanarmon.

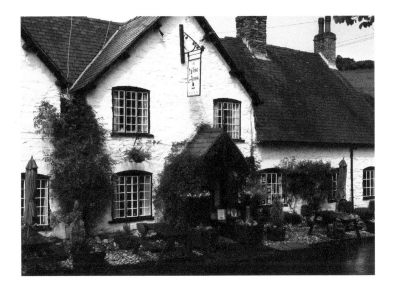

The West Arms, Llanarmon.

58. Chirk Castle

This is a building of historical depth, guarding the entrance westwards to the Berwyns. It was one of the castles Edward I constructed across North Wales. Chirkland was once a Marcher lordship.

In 1593 the castle was bought for £5,000 by Sir Thomas Myddelton. His son, Thomas, fought for the Parliamentarians in the Civil War but became a Royalist in the Cheshire Rising. Following the Restoration, his son became Sir Thomas Myddelton, 1st Baronet of Chirk. The castle passed down the Mydddelton line until 1796, when it was owned by Robert Myddelton-Biddulph. The Myddelton family lived in the castle until 2004.

This is a National Trust property and has well-maintained gardens and parkland.

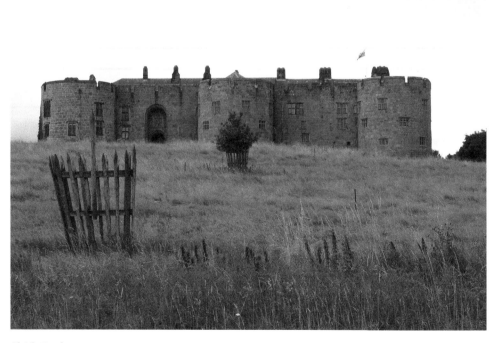

Chirk Castle.

59. Meifod

Magnificently located in the heart of Mid Wales, Meifod is surrounded by rich agriculture and mature trees, which glow in the autumn. With a population of some 1,300, Meifod is a village to the south-west of Oswestry, well within Wales. It is reached from Welshpool and Llanfyllin. It is in the valley of the River Vyrnwy. Historically, it is associated with the Ordovices tribe. Its site includes the setting of the Princes of Wales at Mathrafal, which was also an early Christian centre. It was associated with St Gwydafarch in the sixth century. The seventh-century Prince of Powys made Meifod his summer residence. A church built by Madog ap Maredudd, the last prince of the entire Kingdom of Powys, was consecrated in 1156. Madog has his burial tomb in the churchyard here.

The churches of St Tysilio and St Mary occupy the village centre, dating to the twelfth century. The King's Head is the local pub. There are active rugby and football teams locally. Dyfryn Hall, a Georgian period manor house, was the home of Clement Davies, the Montgomeryshire MP and leader of the post-war Liberal Party between 1945 and 1956.

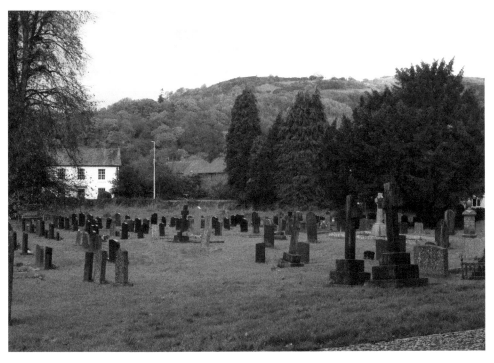

Meifod/Mathrafal.

60. West Felton

With a population of around 1,400, this village includes a Norman castle. It was included in the Domesday Book as 'Feltone' and 'Feltone by le Knokyn' in 1303. The parish church, dedicated to St Michael, has a twelfth-century nave.

Boris Johnson was married at St Michael's Church, to Allegra Mostyn-Owen, on 5 September 1987. The wedding reception was held at her nearby family country home of Woodhouse.

West Felton Church.

61. Chirk Castle Gates

These huge gates are the work of the Davies brothers, Robert and John, of Croesfoel Forge, Bersham. They were created in 1719 and carry the coat of arms of the Myddelton family. They were originally meant to be situated at the forecourt of the castle but were later moved to their present site. The palisades on either side were meant to enclose the castle forecourt. The 'bloody' hand of the family design is next to the eagles' heads and has created a number of stories involving the cutting off of a hand. One describes the imprint of a bloody had on a white cloak worn during a battle. The lodge, in Tudor style, was built in 1888.

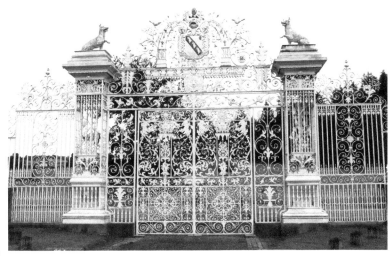

Chirk Castle gates.

62. St Martin's

This is an ancient parish some 5 miles from Oswestry, with four townships running along the River Ceiriog and the Dee forming the border. The Bishop of St Asaph had a palace here, but Owain Glyndwr burnt it down when with his army he attacked Salop.

The church is dedicated to St Martin of Tours, which was part of the diocese of St Asaph until 1922 when it was transferred to the English diocese of Lichfield.

St Martin's has traditionally come under the influence of nearby Chirk Castle and the Trevor family of Brynkinalt, Chirk. In the 2011 census, its population was 4,333.

Its main road, the A5, was built by Thomas Telford through the parish of St Martin's, crossing into Wales at Chirk Bank. He designed a canal linking the industrial areas around Ruabon to the canal network. This is the now active Llangollen Canal.

For several centuries, coal was mined at St Martin's. In 1968 the last coal mine, at Ifton, closed. It was the largest coal mine in Shropshire.

The Keys in St Martin's.

63. Weston Rhyn

With a population of some 2,800, this village is recorded as Westurn in the Domesday Book. The name appears to include the Welsh name for Rome (Rhufain). Oswestry is its post town. The Welsh hills are to the west, as is also Offa's Dyke. Originally a mining village, its mines have closed. The local Church of England is St John's.

Weston Rhyn.

64. The Marches School, Oswestry

This was the first academy school to be created in Shropshire, with an enrolment of around 1,200. It was formed in 1988 with the amalgamation of Croeswylan School and Fitzalan Comprehensive School. Fitzalan was previously two secondary schools for boys and girls separately. The Marches School is co-educational. On Morda Road, the new school was newly built. It was awarded Technology College status in 1996. In 2010 the school was awarded the 'Outstanding' grade.

The Marches School, Oswestry.

65. Rhydycroesau

Within Shropshire, this Welsh-named village is 3 miles on the B4580 out of Oswestry. The church is in Wales and the rectory in England.

Of distinction here is that the first rector was Revd Robert Williams, appointed in 1837. He received an MA from Christ Church, Oxford. He was fluent in the old Cornish tongue

Rhydycroesau.

and wrote a dictionary of it. He also wrote *Biography of Eminent Welshmen* and *History and Antiqueties of the Town Aberconwy.*

In 1920 a referendum was held to decide whether the church should belong to England or Wales; the former won, even though the church is located in Wales.

Rhydycroesau is a place where regular pantomimes are performed each year in the village hall. In 2016 over thirty-six pantomimes had been performed.

66. Welsh Frankton

Welsh Frankton is situated around two-thirds of the way between Oswestry and Ellesmere. A 10-mile branch of the Ellesmere Canal was built between 1798 and 1802 from Welsh Frankton largely to carry limestone quarried from Llanymynech Hill. This is important for agriculture, for soil conditioning and as flux for iron smelting.

St Andrew's Church of 1857, designed by E. Haycock, is on a steeply sloping site. It is of sandstone with an ashlar spire. Decorations mark the east window. It has a high Victorian character with a polygonal stone pulpit.

67. The Fox Inn, Church Street, Oswestry

A small pub with plenty of character, the Fox Inn has a cellar and a backyard. The yard is backed by a tall stone wall, which is said to be the remains of the town wall. Originally a dwelling, some parts originated in 1550.

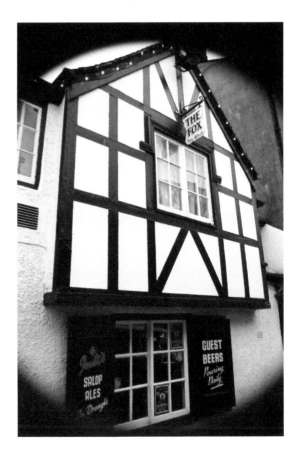

The Fox Inn, Church Street, Oswestry.

68. The Pontcysyllte Aqueduct

This amazing structure, designed by Thomas Telford, has eighteen arches, with the piers in stone and water-holding troughs in cast iron. It is 336 yards long and has a width of 4 yards and a height of 126 feet. It took ten years to build. Four of its piers are in the River Dee.

The main reason why it was built never came to fruition. It was to carry the Ellesmere Canal, which would supply a goods-carrying conduit between the River Severn at Shrewsbury and the River Mersey at Liverpool. Only part of the canal route was completed, and the revenues expected never materialised. It was to be linked to the coal, iron ore and lead deposits of the Wrexham area. These could have created large revenues if their carriage was via Liverpool.

The aqueduct has piers that are hollow above the height of 70 feet. The supply and erection of the ironwork was by William Hazledine of Plas Kynaston Ironworks. The

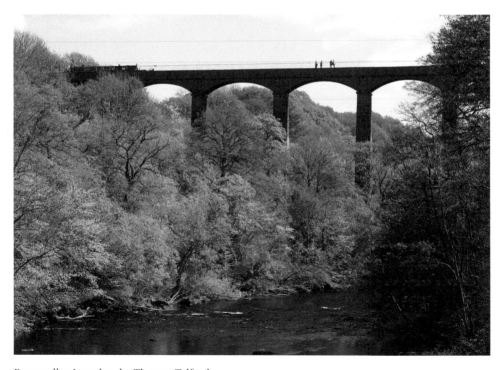

Poncysyllte Aqueduct by Thomas Telford.

original substance used to seal the metal plates was Welsh flannel, impregnated with white lead. In 1804 a narrow waterway was built at the northern end of Pontcysyllte along the Dee past Llangollen, and a large weir was constructed close to the Dee where river water supplied the canal.

William Jessop, engineer, had a major part in conceiving the original structure. The contractor was John Simpson, its supervisor of works was Matthew Davidson; William Reynolds, ironmaster, contributed his knowledge and Thomas Telford was chief.

The opening of the Pontcysyllte Aqueduct was accompanied by gun firing and singing. It was reported that 8,000 people attended.

69. The Cefn Viaduct

Only a half a mile downstream from the Pontcysyllte Aqueduct, this is another spectacular building from the railway age. It carries the railway line across the eastern end of the Vale of Llangollen, through the busy village of Cefn Mawr. The present line from Wrexham to Shrewsbury runs over it, proving its stability. It spans the River Dee, is 1,508 feet in length and stands 147 feet above the river. It has nineteen arches with 60-foot spans.

On a memorable visit to the Cefn Country Park, I met a man sitting on a bench who came here often. 'I love that bridge,' he said. Indeed, it is one of the most beautiful multiple-arch bridges in the UK – an exercise in symmetry and texture. A visit here from Oswestry is well worthwhile.

Henry Robertson was the instigator here. He proposed that the new railway bridge would open markets for Ruabon and Wrexham coal to markets in Chester, Birkenhead and Liverpool in one direction and Shrewsbury in another. Because of hostility from landowners, he had to survey at night. One squire wished that someone would 'throw Robertson and his theodolite into the canal'. However, permission to build the bridge was granted and the railway contractor Thomas Brassey was given the task, which, after two years, was completed in 1848.

It was Henry Robertson, a Scot from Banff, who revived the Brymbo Ironworks, founding the steelworks in 1884 with another Scotsman, Robert Rowe. He worked on the local John Wilkinson mines. He realised that if the potential of local mineral deposits was to be fulfilled, there had to be transport by rail, so the North Wales Mineral Railway was created. Robertson was the engineer and designer of the railways radiating from Shrewsbury including the line from Ruabon to Llangollen, Corwen and Bala.

The Cefn Mawr Country Park is located close to the viaduct, situated over the Dee. It has an open aspect, which attracts families with children who are also attracted by the display of small animals and two llamas.

Cefn Viaduct.

70. Penson's Holy Trinity Church, Oswestry

Situated at Salop Road, this was designed by Thomas Penson in 1835–37. It has a wide nave, which was built in sandstone with lancet windows and thin buttresses. In 1894 a chapel and transept were added in art deco style. Inside the apse is decorated. The font is in alabaster and veined marble. This is one of Penson's finest church designs.

Penson's Holy Trinity Church, Oswestry.

71. Municipal Buildings, Oswestry

The Municipal Buildings were created in 1892–93 by H. A. Cheers with T. M. Lockwood of Chester as consulting architect. The walls are sandstone ashlar on four sides, and the steep roof tiles are marked by tall rectangular chimney stacks. There are two storeys with an occasional third. The front, towards Bailey Head, is symmetrical, and displays images of St Oswald. The council chamber has three large windows. Law courts were held in this building.

This large decorated building, facing a spacious square, is reminiscent of the centre of towns in France. The top floor is the town museum. Locals call it the Guildhall.

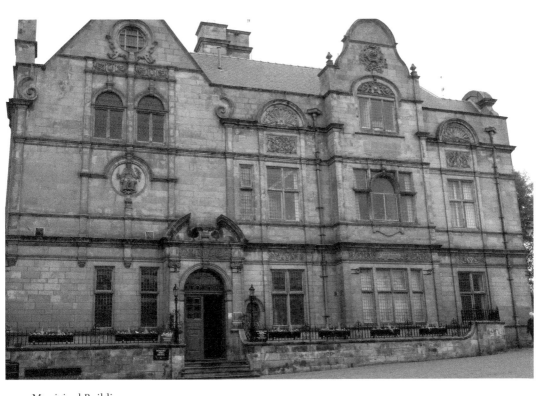

Municipal Buildings.

72. The Cornovii Tribe

The Cornovii were Celtic people of the Iron Age and Roman period. They occupied north-west England including Shropshire, Cheshire and Staffordshire, as well the Mersey area. Another tribe of the same name occupied Cornwall and the South West. These Midlands Cornovii also lived in what is now Wrexham and Oswestry. Chester was one of their significant centres. Other associated tribes bordered them: the Brigantes to the north, the Corieltavi to the east, the Dobunni to the south and the Decangli and Ordovices to the west. They continued under Roman occupation, centred on Viraconium (Wroxeter).

The fist mention of the tribe is in Ptolemy in the second century AD. They were known to mine salt in Cheshire and carry it in coarse pots. They lived on hills and created metalwork. The Oswestry old hill fort is thought to have been occupied by this tribe. The Celtic Caractacus is thought to be from this tribe, leading a resistance in AD 50.

They had a developed economy and had cereal crops in the lower valleys. They lived in round houses and used iron in implements. They bred cattle and pigs and during the Roman occupation they learned new ways of building and husbandry. The Kingdom of Pengwern joined with Mercia in AD 642.

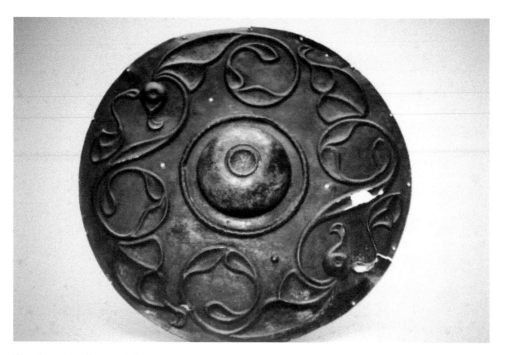

The Cornovii tribe symbol.

73. Bellan House School, Oswestry

Bellan House is a private junior school, part of Oswestry School, occupying a prominent building in Church Street. It is Georgian in style and was built in 1776 for Robert Lloyd. It has a Palladian seven-bay front and has three storeys. The central porch has two full Ionic columns.

It has a wide curriculum range and uses the facilities of the nearby Oswestry School, including heated swimming pool, playing fields and gymnasium. Performing arts clubs include modern ballet, dance and drama. Music is prominent, including a choir and instrument playing. Sports featured include football, hockey, rugby, cricket, netball, swimming, tennis, rounders, athletics and cross country, and there is a mini-football academy for two- to six-year olds on Saturday mornings.

Pupils arrive between 7.45 a.m. and 8 a.m., when breakfast is provided. Pupil supervision can be provided until 4.30 p.m., although pupils can be kept until 6 p.m. with a small snack.

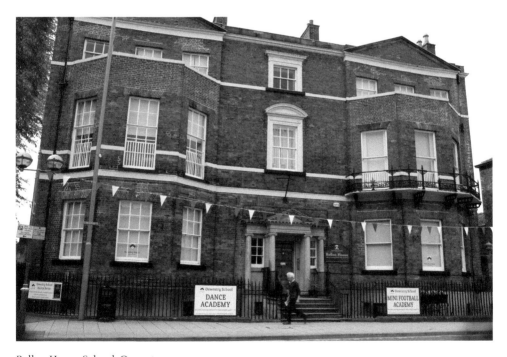

Bellan House School, Oswestry.

74. Hill Farmer Statue

Located in Smithfield Street, Oswestry ('More a square than a street', wrote Newman and Pevsner), because of the colouring of the paving, the locals call it 'Red Square'. On a stone mound at the Church Street end, this sculpture is a bold and realistic depiction of the farmers who cultivated the sheep-strewn highlands to the west.

Ivor Roberts-Jones can be seen as having created a fine work of art. Unfortunately, the farmer's face is looking at Church Street, which is along the direction of the sun, so the farmer's front of body is often in shadow, regrettable because the face and torso are very impressively modelled; they speak of the Berwyn Mountains and their economy.

Formally called *The Borderland Farmer*, this is a fitting memorial because Ivor Roberts-Jones was born in Oswestry in 1913. After education at Oswestry School, he attended Worksop College, then Goldsmiths College and the Royal Academy of Arts, London. During the Second World War he served in Burma. From 1964 he taught sculpture at Goldsmiths, London.

His first commission came in 1964 when he was asked to depict the British painter Augustus John, which took three years to complete. However, it was completed in 1967

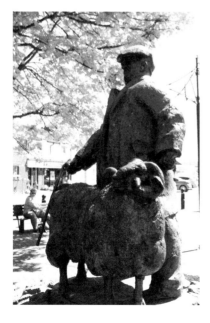

Hill farmer statue.

and the artist was elected as an Associate of the Royal Academy. This piece was erected in Fordingbridge, Hampshire, near John's last home.

In 1971 he was commissioned to produce the full-length statue of Winston Churchill that now stands in Parliament Square. The first work was criticised by the organiser of the appeal to raise money: 'The cheeks, the eyes, the forehead and the top of the head require improvement.' This was done and the piece is much admired.

The sculptor has created heads of notable people including Yehudi Menuhin and George Thomas, Viscount Tonypandy. Harlech Castle features Roberts-Jones's 1984 statue *The Two Kings*.

75. Nos 4–6 The Cross, Oswestry

Centre of attention here is architect Frank Shayler (1867–1954). Originally from Oxfordshire, he joined the practice of W. H. Spall in Welshpool; subsequently he created his own practice in Welshpool and Oswestry. He worked with decorated stone and was a master of the Arts and Crafts style.

In 1905–06 he worked on a design for the National Westminster Bank in Oswestry. It has a curved façade of Grinshall ashlar, rounded off to the north with a domed turret. There

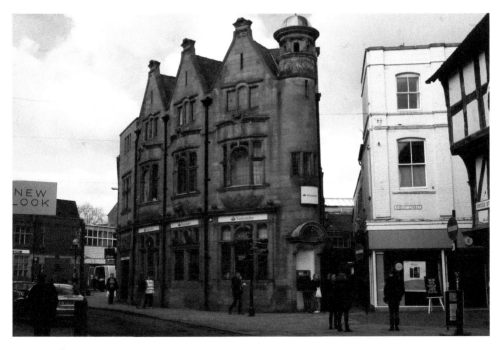

Nos 4–6 The Cross, Oswestry.

are first-floor oriels under three steep pedimented gables, which have stone carvings and prominent rainwater downpipes.

He designed Llanidloes Town Hall in 1908. With Taylor and Rodge, he designed Llanfyllin Wesleyan chapel with Ionic columns. In 1904 he designed the Sion Wesleyan Chapel, Llanrhaeadr-ym-Mochnant. It has a slate roof, is stone built and was designed in the Arts and Crafts Gothic style. Grade II listed, it is regarded as one of the best in Wales.

The Old Rectory in Gobowen is also his design, as is the Robert Owen Memorial Museum, Newtown.

76. Welsh Walls, Oswestry

A very old name, this street is located in central Oswestry between Cae Glas Park and Brynhafod Road.

Previously the Dining Rooms and before that The National School, located here, opened in 1841 as a provision for junior children with accommodation for the headteacher. It was opened in 1992 as the Walls Restaurant. The limestone building is Gothic in style.

The 'Welsh Walls' street name is redolent of early history defences. Oswestry has been subject to many attacks. In the early thirteenth century King John came and ravaged and in 1215 Llewelyn ap Gruffydd brought his army to Oswestry. In 1257 John Fitzalan II, Lord of Oswestry and Clun, received a grant to build a wall for the defence of the town. However, this may not have been a strong stone structure; it may have been a bank and ditch with wooden palisades. It was demolished by 1600. Despite investigations, the precise route of the wall has not been discovered. The street name is the only evidence for its placing and existence.

Welsh Walls, Oswestry.

77. John Leland's Visit to Oswestry

The antiquarian visited Oswestry in 1539. He made a number of factual observations, writing (original spellings):

The compace of the town within the walls is about a mile.

There are four gates, the New Gate (Portnewith) by south.

The Black Gate, alias Portdee, by south east towards Shrobsbyri.

The 3. Beteriche Gate, whence is the road of the same name which leads to the town, north est toward Chester.

The no 4 Williho Gate, alias Mountain Gate, because through this one travels to nearby mountains almost four miles distant, north west toward the mountain of Penllin in Merioneth.

There are no towers beside the walles beside the gates. The town is diked bout and the brokes run in to it. The Church of St Oswald is a very faire ledded church with a torrid steeple, but it standeth without the new gates; so that no chiroh is there within the towne.

Theer is a castelle set on a mound more likelihood made by hand and ditched by south west betwist Beterice Gate and Williho Gate, to which the town waul commit.

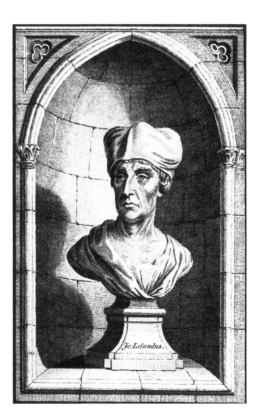

John Leland.

78. Chirk Aqueduct

One of the four dramatic bridges to the north of Oswestry, in a magnificent cluster, Chirk Aqueduct crosses the River Ceiriog and the Welsh border on the edge of Chirk. It was originally built in 1795–1801 by William Jessop and Thomas Telford to carry the Llangollen branch of the Ellesmere Canal. At 70 feet high, 696 feet long with ten arches, laid in rubble mined locally, it has shallow arches with a cast-iron railing rising from a cornice moulding.

This construction was a great credit to designer Telford. His first plan was to cross the valley with an embankment; however, Jessop, the company's chief engineer, proposed a bridge instead. In 1794, working under Jessop, Telford proposed an all-masonry shaft rather than an iron trough. Part of the higher structure is hollow, thus reducing the top weight.

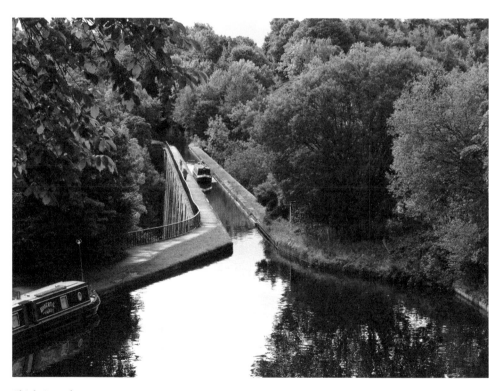

Chirk Aqueduct.

79. Chirk Viaduct

Immediately upstream of the Chirk Aqueduct, Chirk Viaduct was designed by H. Robertson. Built in 1848 to carry the Shrewsbury & Chester Railway, it is 106 feet high, 2,049 feet long and sixteen arches of rock-faced limestone. Three arches at each end are of a different build. This railway-carrying bridge overlooks the close-by aqueduct.

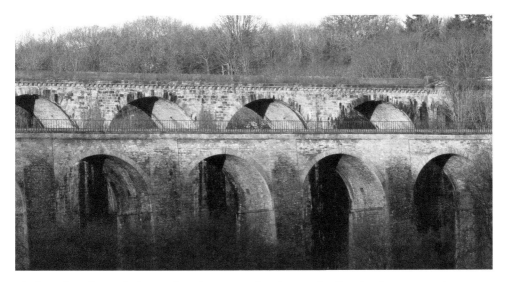

Chirk Viaduct above Chirk Aqueduct. (Courtesy of Andrew under Creative Commons 2.0)

80. Ardmillan, Oswestry

Ardmillan House is close to the railway line, on a raised sector, on Walford Road. The roof is steep, tile-banded, iron-crested and can be seen rising above trees. It was built for a former mayor of Oswestry, John Thomas, dated 1879. Newman and Pevsner write: 'Though isolated in a twentieth-century housing estate, it is a Victorian monstrosity so breathtaking that it deserves to be cherished. Sadly, the architect's name has not been discovered. Lofty walls of cream brick with red brick bands. A gargantuan balustraded porch on quatrefoil piers with Romanesque foliage caps, all jostle for place, obscuring the simplicity of the squarish plan.'

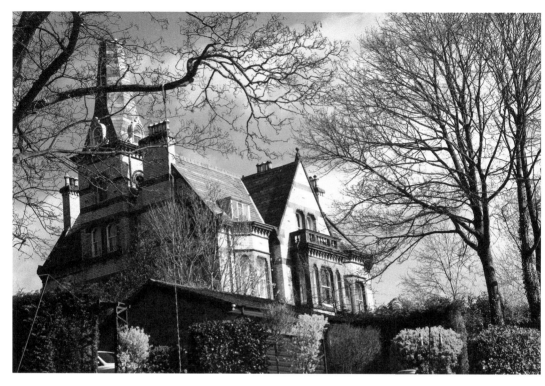

Ardmillan, Oswestry.

81. Oswestry's Original Theatre

In Willow Street many houses have plaster-covered half-timbering. One newer building was owned by William Ormsby-Gore and built as a theatre. It was fitted out with boxes, a pit and a gallery and was well supported. Mr Charles Stanton gained a reputation as an excellent manager. In 1823 a volunteering group of locals performed here. One night takings of over £76.00 were reported. Mr William Betty, a well-known actor, took the stage at the Oswestry Theatre a number of times. The tall brick building was later used as a brewery.

Oswestry's
original theatre.

82. Oswestry – a Market Town

William Cathrall writes vividly in 1855:

> Oswestry is a market-town and the chief market is held every Wedsesday. It is
> abundantly supplied from the surrounding highly-cultivated agricultural country, and
> the articles brought for sale are generally of the very best quality. Welsh mutton, poultry
> and fruits of rare delicacy are among the choice morsels which the exquisite gourmand
> may ever find, in their due season, in Oswestry market. Apples and pears, produced in
> the vicinity, and offered for sale here, might successfully vie with the best of the fruits
> grown in Guernsey, Jersey, of the sunny orchards of Kent. There is a small market held
> on the Saturday, principally for the accommodation of the numerous labouring classes
> employed in the neighbourhood.
>
> Twelve fairs are held in the town, all of which are conducted with great spirit, and
> attended by large classes of buyers and sellers. A Fair is held on the first Wednesday of
> every month.

Facing the Castle Mound, at the head of Bailey Head is the Market Hall, which has indoor
markets on Wednesdays, Fridays and Saturdays. The inner space has a balcony. It includes
many traders and a café. Outside, open-air stalls sit in the square.

Oswestry Market.

83. Beatrice Street, Oswestry

The name is said to derive from Beatrice, the queen of Henry IV (1366–1413). There was originally a Beatrice Gate here, built probably when the king visited the town during his confrontations with the insurgent Welsh.

The gatehouse was a handsome building with a guardhouse on each side. It had the arms of the Fitzalans, a lion rampant, at its head in plaster. It is said to have been built by Thomas, the Earl of Arundel. It was demolished in 1782, along with the two other town gates. Black Gate was demolished in 1766.

84. John F. Kennedy Visits Oswestry

David Ormsby-Gore was MP for Oswestry. During that time a visit was made to his home in this town by John F. Kennedy, the USA's thirty-fifth president, who took the presidency in January 1961. He was accompanied by his wife, Jackie.

During their visit, the Kennedy's explored the town, where they were observed in the streets and also sat in on a service at the Catholic church.

Later, as Lord and Lady Harlech, the Ormsby-Gores moved to Washington where he was ambassador. He was a close advisor to the president during the Cuban Missile Crisis. The president was assassinated at Dallas in November 1963.

In 1985 Senator Edward Kennedy and his sister Jean attended Lord Harlech's funeral in Oswestry, which was also attended by Jackie Onassis.

John F. Kennedy visited Oswestry.

85. Shropshire

One of Britain's beautiful, open, agrarian counties to the centre west, Shropshire is the eastern border of Wales with England. Newton and Pevsner describe Church Stretton and Ludlow as 'Georgian market towns ... these are the star attractions.' They identify 'the stone-walled sheep fields in the borderland beyond Oswestry'.

Shropshire is England's largest inland county. It touches on the industrial West Midlands through Telford New Town, established in 1968, which is now the county's largest town. In 2001 Shropshire's population was around 441,000. The River Severn marks a division, entering the county 12 miles west of Shrewsbury and leaving in the extreme south-east.

The landscape to the west of Oswestry is 'entirely Welsh in character ... The plains are their most characteristic around Wem and Ellesmere, with their cluster of meres'.

Evidence of human occupation goes back to the fourth century BC. Barrows, cairns and standing stones 'indicate Bronze Age ritual and funeral rites. The much more conspicuous hill forts of the Iron Age show the pattern of settlement and defence in the last centuries BC. Their location, with the exception of Old Oswestry, in general shows little or no relationship to their settlement patterns'.

Throughout the county, the traditional building materials were stone, brick and timber framing, in differing combinations. Timber in buildings started in prehistoric times and continued until the end of the seventeenth century. Oswestry has a few buildings that reveal their mode of construction but there are many others where façade plaster has been applied over the original materials. The underlying ground material in the Oswestry district is of Jurassic origin.

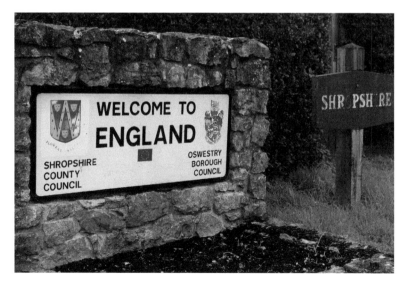

Shropshire.

86. Bailey

This word signals a castle. The traditional castles had an inner bailey and an outer bailey. Each area was used by its inhabitants, both for defensive purposes. The outer bailey had a curtain wall and the inner bailey came inside the centre area, with accommodation inside, and was heavily guarded.

Oswestry's Bailey Street is a busy pedestrianised shopping street starting at Cross Street, next to Lloyd's Mansion, and rising to a handsome open square close to the Castle Mound. The top, where the Guildhall is set, is called The Bailey Head. The George, a pub, is located here, and there is also The Bailey Head on the square.

Bailey Street, Oswestry.

87. Morda Road, Oswestry

Ian Woosnam OBE bought a house on Morda Road, near the cricket ground. Newman and Pevsner wrote: 'in Morda Road two later villas which catch the eye. They were probably built *c.* 1910. Both have symmetrical red-brick fronts framed by canted window bays. "Mair Wen", parapeted, is moving towards neo-Georgian. "Edenholme", more original, is an ingenious composition of grey slate roof slopes.' Their architect is thought to be Frank Shayler.

Morda Road, Oswestry.

88. Sir Henry Walford Davies (1869–1941)

One of Britain's outstanding musicians, Sir Henry held the title of 'Master of the King's Music, following Sir Edward Elgar', from 1934 until 1941. In 1898 he received a doctorate in music from Cambridge University. In 1922 he was knighted in David Lloyd George's resignation honours list.

Born in Willow Street, Oswestry, he was the seventh of nine children of John Whitridge Davies and Susan (née Gregory). His father was an accountant by profession but was a keen amateur musician. He founded the choral society at Oswestry and was choirmaster of the local Congregational church, known as Christ Church. In 1882 Henry was accepted as a chorister at St George's Chapel, Windsor. In 1924 he was appointed Gresham professor of music at the University of London. His 'Solemn Melody' has been a regular feature of the London Remembrance Cenotaph event.

For a long period he was chairman of the National Council for Music and was an advisor for music at the BBC. He made broadcasts on music for the BBC and lived in Bristol to be close to the BBC Symphony Orchestra at the outbreak of the Second World War. His compositions were many and varied including symphonies and overtures.

Sir Henry Walford Davies.

Acknowledgements

The author wishes to thank Christie Evans of Fineline, Clwyd Street, Ruthin, Denbighshire, for her work on the images. Also, he thanks Marcus Pennington, editor at Amberley Publishing, for his capable work in putting the book together.